T0153497

LITTLE BOOK OF

VERSACE

To Ramon

This book is a publication of Welbeck Non-Fiction Limited, part of Welbeck Publishing Group Limited and has not been licensed, approved, sponsored, or endorsed by any person or entity. Any trademark, company name, brand name, registered name and logo are the property of their respected owners and used in this book for reference and review purpose only.

Published in 2022 by Welbeck
An imprint of Welbeck Non-Fiction Limited,
part of Welbeck Publishing Group.

Based in London and Sydney
www.welbeckpublishing.com

Design and layout © Welbeck Non-Fiction Limited 2022
Text © Laia Farran Graves 2022

Laia Farran Graves has asserted her moral right to be identified as the author of this Work in accordance with the Copyright Designs and Patents Act 1988.

All rights reserved. No part of this publication may be reproduced, stored in a retrieval system, or transmitted in any form or by any means, electronically, mechanical, photocopying, recording or otherwise, without the prior permission of the copyright owners and the publishers.

A CIP catalogue record for this book is available from the British Library.

ISBN 978-1-80279-263-8

Printed in China

10 9 8 7 6 5 4 3

MIX
Paper | Supporting
responsible forestry
FSC® C020056

LITTLE BOOK OF

VERSACE

The story of the iconic fashion house

LAIA FARRAN GRAVES

WELBECK

CONTENTS

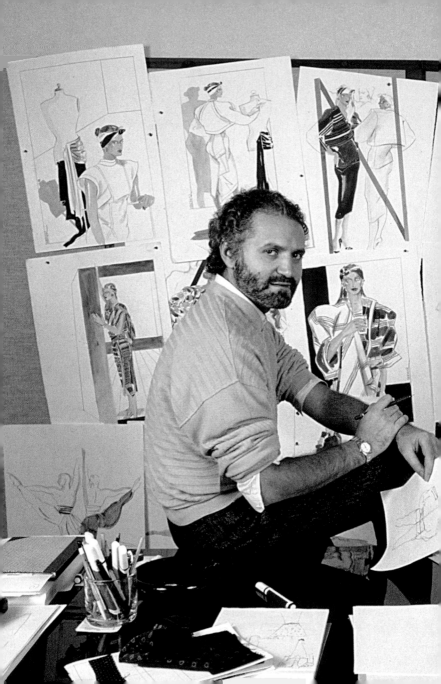

INTRODUCTION

"I want to be remembered [as] a man who tried to [break] barrier[s] in fashion, to put fashion on the street, to influence people in the best way." – Gianni Versace

Gianni Versace was one of fashion's greatest innovators of all time: a superstar designer and a visionary. He was adventurous and full of curiosity for the world around him, and had a surprising ability to capture the moment and to keep reinventing himself. He was an artist, passionate about his work and unafraid to take risks or break rules to create beauty and fantasy on the catwalk. He was a man who made his own dreams come true.

Born on 2 December 1946, he was brought up in Reggio Calabria, Southern Italy, an area skirted by the Mediterranean Sea. In his own words, he "came from a fashion family". His father, Antonio, was a businessman; his mother, Franca, was a successful dressmaker, a strong woman he described as "ahead of her time" and to whom he was devoted. When Gianni was growing up, her studio was his playground, where he was surrounded by 45 seamstresses and first learned to make clothes.

OPPOSITE Gianni Versace in 1985 in his studio in Italy, where he would begin the design process. Here, he poses with some of his sketches.

After leaving school, he studied architectural drafting before dropping out to go back to work with his mother, as a buyer and designer. There, he dressed Alda Balestra, Miss Italy 1970, a moment that would be the starting point of his long-lasting synergy with the media, show business and celebrity worlds, underpinning the importance of product placement. He has been credited with creating the concept of the supermodel – by booking models exclusively for his runway shows at considerable fees, and casting them again in his editorial campaigns, categories that had previously been kept separate. He is also known for courting celebrities and inviting them to sit in the front row for his presentations. Gianni's love of music was a great source of inspiration and he would often collaborate with artists, sometimes also featuring them in his shows and advertising campaigns, redefining glamour and shaping the fashion landscape as we know it today.

"I think the strength of Versace is the family group."

– Gianni Versace

In 1972, Gianni Versace was hired to design for knitwear company Florentine Flowers, but soon moved to Italy's new fashion capital, Milan, to work on his first collections for Arnaldo Girombelli, owner of the labels Genny, Complice, and Callaghan. In 1978, backed by the Girombelli family, he founded his own fashion design house, which he called Gianni Versace – later to be shortened to Versace. That same year, he opened his first boutique in Milan's celebrated Via della Spiga. From its inception, the brand was a family affair, something

that was integral to its success, providing him with a strong foundation and a sense of identity. His brother Santo took care of the finances, and after their mother's death in 1978, their sister Donatella left the University of Florence to join them in Milan. He and Donatella were incredibly close, always working side by side and discussing everything. She became Gianni's sounding board, muse and main influencer, and provided a strong female perspective.

In contrast to his glamorous and exciting work, Gianni Versace was an intensely private and softly spoken man. He was also highly cultured – an avid reader and an art collector. His open-mindedness was greatly inspired by Karl Lagerfeld, to whom he referred as his *maestro*.

BELOW Gianni enjoying family time, playing with his niece Francesca and two puppies.

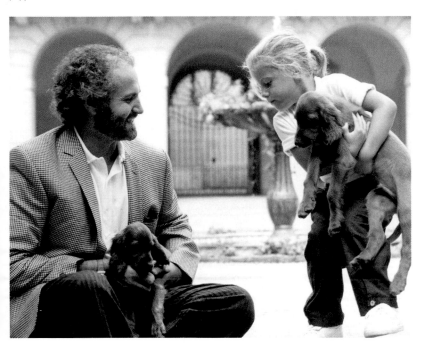

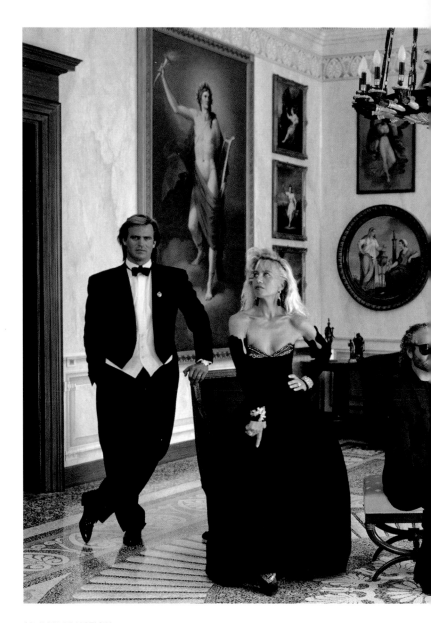

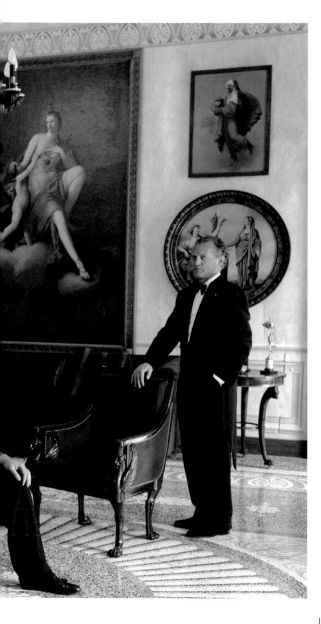

LEFT Gianni and
sister Donatella in
their spectacular Lake
Como residence in
1988, to which they
would sometimes
retreat, or use to
entertain celebrities.

Initially, Gianni Versace used his name as his company logo. This was later replaced with the iconic head of the mythological Medusa, a strong visual reference that no doubt reminded him of the ancient Greek and Roman floor mosaics in the ruins in the Reggio Calabrian peninsula, where he played as a child. Classicism was such a strong influence on his work that it became part of his handwriting, and the Medusa's stare encapsulated the spirit of the brand, for she turned men to stone with just her gaze.

In 1982, his Autumn/Winter collection won him the prestigious Milanese award L'Occhio d'Oro – meaning "golden

BELOW Versace's iconic Medusa-head logo, seen here, may have been inspired by the knocker on the main door of the Versace Palazzo on Via Gesù, which the family acquired in 1981.

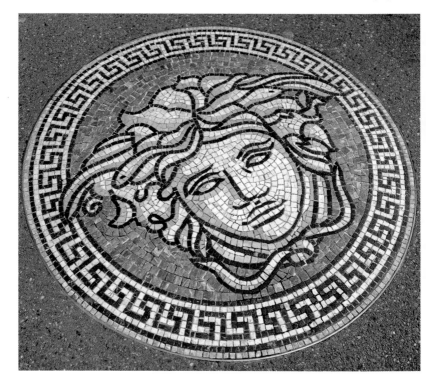

eye" – for best designer, putting him firmly on the fashion map. It was the first time he had used Oroton, a metal fabric made out of small connecting discs with a similar texture to mesh, so fluid that it could be draped and embellished. It was also the first year he had designed costumes for a ballet – Richard Strauss's *The Legend of Joseph* at Milan's famous opera house Teatro alla Scala – an interest he would pursue over the years. His exquisite craftmanship and technique, and his fascinating use and choice of fabrics and their combinations – such as contrasting leather with georgette silk – didn't go unnoticed, and in 1985, he was invited to hold a grand dinner and fashion show at the Victoria and Albert Museum in London, with Raphael's full-scale Renaissance tapestries as his backdrop.

"Those who fall in love with the Medusa have no way back."

– *Vogue* on Gianni Versace

Gianni Versace's global success continued, and in 1989 he launched his haute couture line, a strategic business decision instigated by brother Santo, which he called Atelier Versace. The atelier – French for "workshop" – was an experimental space that he likened to a laboratory of ideas, not only to create high fashion and exquisite luxury to be shown in Paris, but also a place to develop new projects and to create magnificent costumes for ballet and theatre productions all over the world. That same year, he brought out Versus Versace, a vibrant, youthful and more accessible diffusion line, as a gift to his sister, Donatella. As the business grew, other additions were made: Signature (Versace classics with a lower price tag); Versace Jeans Couture, which encapsulated high fashion with

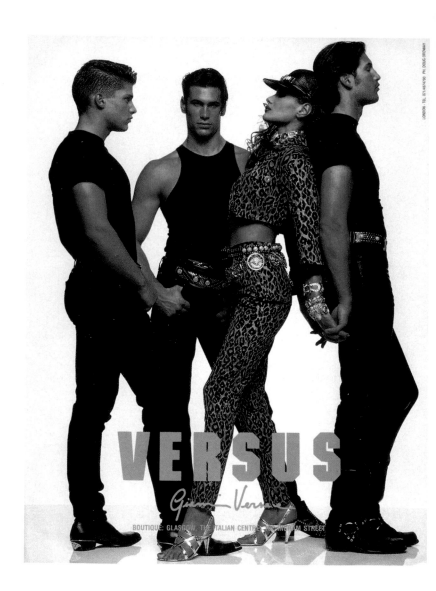

VERSUS

Gianni Versace

BOUTIQUE: GLASGOW, THE ITALIAN CENTRE, INGRAM STREET

LONDON - TEL. 071/482/4700 PH. DOUG ORDWAY

streetwear; and a children's collection, Young Versace. Soon a perfume line and homeware were also incorporated into the Versace empire, making the brand accessible to mass popular culture. By the 1990s, everybody wanted to experience the Versace lifestyle, and at last, they could.

Then tragedy struck. On 15 July 1997, Gianni Versace was shot dead outside his Miami residence, Casa Casuarina, as he returned from a short walk. The world was in shock as the horrific news spread, resonating and causing ripples beyond the fashion sphere.

"You have to really break a barrier every day. Fashion, to me, [is] born and die[s] every day."

– Gianni Versace

Donatella took over the company as Creative Director and has remained at the helm ever since, later working as Chief Creative Officer.

According to *The New York Times*, at the time of Gianni Versace's death, the business had enjoyed sales of over $800 million, there were 130 boutiques worldwide, and 50 per cent of the fashion empire was left to his niece Allegra. In 2018, Versace was acquired for more than $2.12 billion by Michael Kors Holdings Limited, later renamed Capri Holdings Limited, which also owned Jimmy Choo. By then, the Versace Group had over 200 boutiques and 1,500 wholesalers worldwide; for 2023, they project a fiscal revenue of $6.1 billion.

OPPOSITE Versus Versace's campaigns have become synonymous with the 1990s aesthetic, as seen in this leopard-print look accessorized with contrasting gold belt, jewellery and high-heeled shoes.

THE GIANNI
YEARS

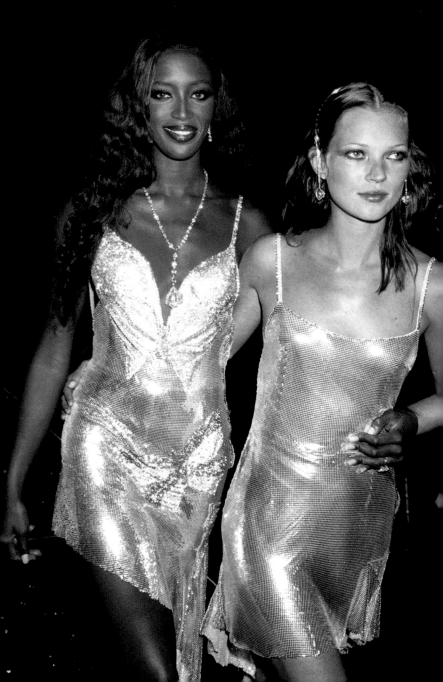

THE MAN OF
THE MOMENT

**"I always claim for quality, I scream for quality,
I love quality."– Gianni Versace**

G ianni Versace would begin the design process by writing
in his daily journal, where he developed the ideas that
would translate into his creations. He worked from
sketches, was a skilled tailor, but also draped garments directly
on to mannequins or models in his studio, as he'd watched
his mother do as a child. Fashion editor Diana Vreeland, who
observed him backstage in 1977, later said that she'd never seen
anyone drape a dress so well and in such little time.

From the outset, the designer drew from the past and looked
to the future, exhibiting an extraordinary sense of intuition. He
had a talent for capturing people's moods and fashion appetite,
and for redefining luxury by making it aesthetically relevant.
His style was one of a kind. It was the product of both his
uncompromising love of quality and exceptional techniques –
both rooted in his heritage and in traditional training – and his
surprising use of themes and contrasting fabrics. It reflected his
boldness and spirit of defiance.

OPPOSITE Models Naomi Campbell and Kate
Moss attend the De Beers/Versace "Diamonds Are
Forever" celebration at Syon House, London, in June
1999, wearing Versace Oroton short dresses in silver.

Gianni's early work was seen as experimental and subversive – not only conceptually, but also in relation to the materials he used and combined. He was interested in all aspects of fabric, from their weight to the finished look, and he studied and developed them, working closely with textile manufacturers to create specific finishes, such as unusual weaves and original tweed patterns. He also padded, layered and overlapped materials to produce new textures and effects (Spring/Summer 1986). In 1982, he launched Oroton in a collection shown at the Paris Opera. This was a featherlight fabric suggestive of chain mail (reminiscent of medieval warriors), which he created with the help of a German textile factory. It could be dyed or patterned and was mostly used in silver or gold (Autumn/Winter 1997). Figure-hugging and with a look of dripping mercury, Oroton would soon become synonymous with the brand and its supermodel glamour, and was used for creating sensational and stunning pieces throughout Gianni Versace's career. Another controversial contribution to the runway was his use of plastic, especially in haute couture. In his Autumn/Winter 1994 show, for example, he applied a varnish to silk, making it look like vinyl (PVC-coated silk) in a collection he termed "technoglamour". He also made dresses and suits of PVC and latex rubber, sometimes adding embellished plastic or with embroidery detail – like the vinyl plastic with diamanté and bead appliqués he showcased in the Couture Autumn/Winter 1995 show, a courageous and triumphant move.

Leather was one of Gianni Versace's favourite materials and, in 1976, he brought out an entire leather collection (which he combined with silk) for Italian label Complice, something nobody had done before. His very first Gianni Versace Collection, in March 1978, also featured leather heavily. It

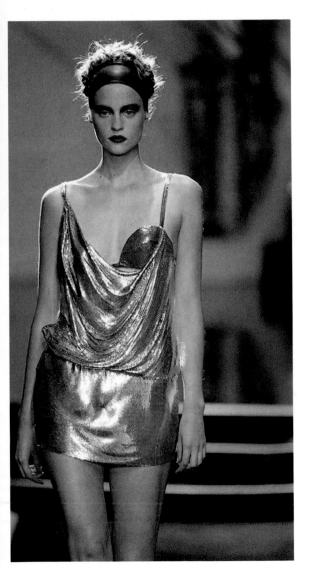

LEFT One of Gianni Versace's signature materials was chain mail. He was able to drape it like fabric, retaining its fluidity – as in this Atelier look from his Byzantine-inspired final show in 1997.

NEXT PAGE Donatella surrounded by a group of models in silver Oroton dresses at the "Diamonds Are Forever" fashion show. Left to right: Erin O'Connor, Natane Adcock (later Natane Boudreau), Naomi Campbell, Kate Moss, Donatella and Amber Valletta.

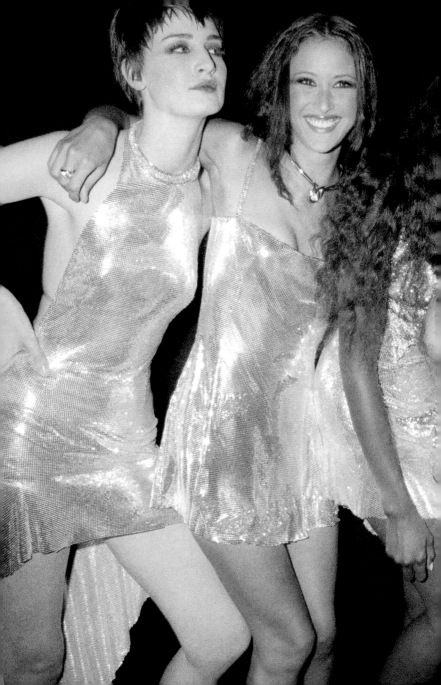

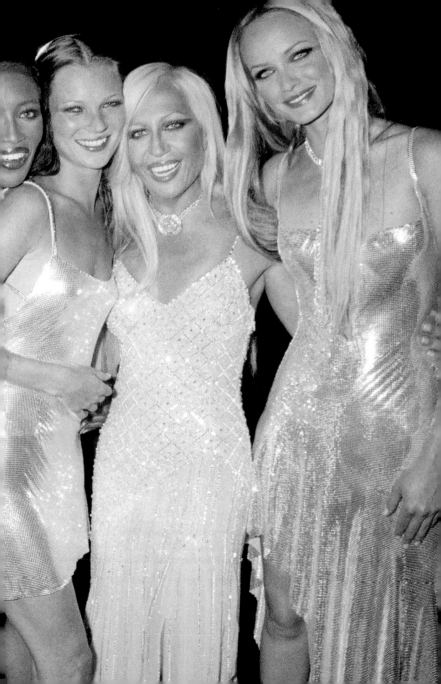

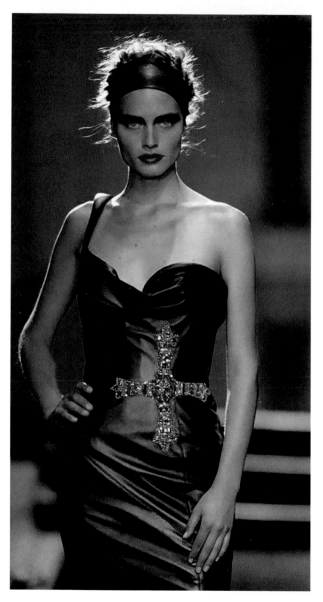

LEFT Leather was one of Gianni's favourite materials. Here, in his interpretation of a goth aesthetic for his A/W 1997 show, a dress is embellished with a Byzantine-style cross, inspired by "The Glory of Byzantium" exhibition Gianni had seen at the Metropolitan Museum of Art in New York.

was shown on the top floor of the Museo della Permanente (Milan's contemporary art museum) and combined looks from the labels Genny, Complice and Callaghan with his own label. They echoed military uniforms, reflecting Italy's political unrest at the time, with the kidnapping and later assassination of former Prime Minister Aldo Moro by the left-wing militant organization the Red Brigades. He also experimented extensively with leather and worked with it in unusual ways, displaying his love for transposing fabrics: he blended it with silk; he padded, quilted and pleated it; he mixed it with mesh and imprinted it; and embellished it with gilt, sequins, beads, lace, fur and astrakhan trim (Autumn/Winter 1992), forming new and surprising surfaces.

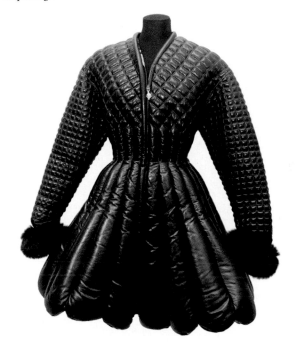

LEFT A technically challenging leather coat – padded, quilted, and trimmed with fox fur – beautifully executed for Versace's A/W 1992 show.

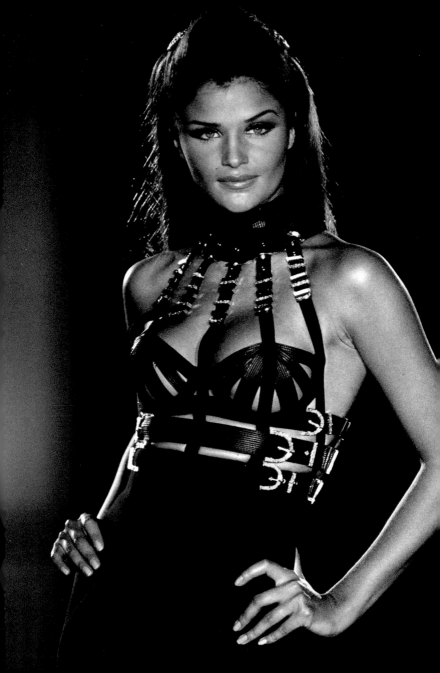

Silk, traditionally the essence of luxury, was another fabric loved by Versace. He used it in its pure form, emphasizing its cascading drapery qualities (Spring/Summer 1995), and at times combined it with other materials including leather or plastic, or employed it to create accessories like his controversial bondage harnesses decorated with golden buckles, chains and strap detailing (Autumn/Winter 1992).

"I like the weight of fabrics, when I need some fall of the dress ... I really have to understand fabrics, I study a lot about fabrics and do my own fabrics ."

– Gianni Versace

OPPOSITE Helena Christensen modelling an outfit from the controversial S&M-inspired A/W 1992 collection, featuring harnesses and straps with golden buckles attached to a collar.

His passion for quality and his purist dedication to work are encapsulated in the silkscreen process that was undertaken by the most skilled printers in the world to create his illustrious prints. Forty-metre batch lengths (just enough to make 10 short dresses) would be printed at any one time, a process that took about eight months from start to finish. To create a print like his Baroque Seashell (Spring/Summer 1992), for example, he would design it, then transfer it on to a stencil and, finally, apply anywhere from eight to 23 colours to it. It would take 20 minutes per colour, per print, applied within precisely one tenth of a millimetre between colours. His prints were to become as iconic and recognizable as the materials themselves, and copied throughout the world. He found it flattering: referring to his Trésor de la Mer print (Spring/Summer 1992), he said: "It's copied everywhere and it's a great compliment to give to me. I saw this copy [in] every country, in America, in Japan, everywhere, and I'm so pleased."

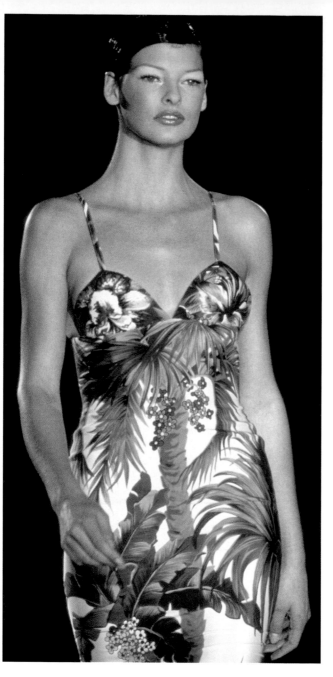

LEFT Linda
Evangelista in
Versace's S/S 1993
show – a collection
inspired by the bright
colour palette of
Florida's South Beach
– in a dress featuring
palm trees and
tropical flowers.

OPPOSITE Karen
Mulder for S/S 1992 in
silk baroque, rococo
and leopard prints
in gold tones, which
became synonymous
with the Versace look.

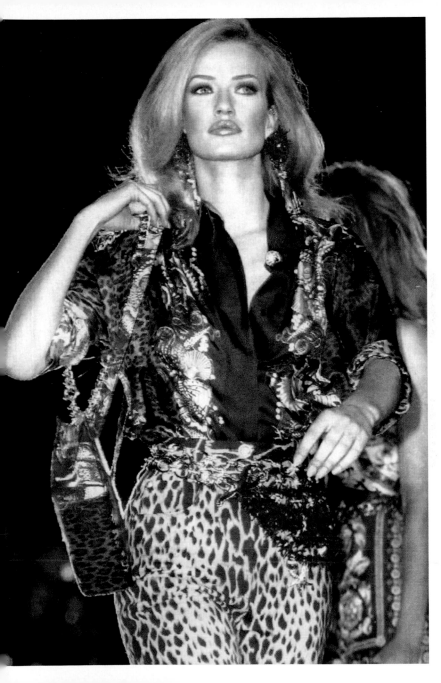

His scarves and foulards, mostly screen-printed, combined classical themes with unlikely patterns – Op art and geometry, animal prints with baroque volutes, neoclassical geometrical forms and meander shapes (Autumn/Winter 1992), or religious icons with bright colour block backgrounds (Autumn/Winter 1991). As well as using screen-printing techniques (Spring/Summer 1991), he occasionally applied discharge-printing by hand (Spring/Summer 1986). And for his first haute couture show in Paris, for Atelier Versace, he chose luxurious silk velvet and hand-painted it with gold pigment. The result? Strikingly executed showstoppers that could not be ignored.

> "The future is in technology, twenty-five per cent of my work on any collection is dedicated to technological research. It's all an evolution. Basically, I'm working with the same silhouette. The news is in the materials."
>
> – Gianni Versace

KEY COLLECTIONS

In the 1990s, fashion became accessible. The lines between catwalk, editorial and everyday life were blurring, and designers became celebrities in their own right. Gianni Versace was acutely aware of the importance of his personal and professional image, and surrounded himself with celebrities and extreme beauty to attain consumer desirability. Atelier Versace was created around this time as an extension of the designer's public relations arsenal, and its first presentation (Autumn/Winter 1989) was shown as an exhibition, displayed on 62 steel torsos, in the

RIGHT Bright colours and graphic patterns were key to Gianni's S/S 1991 "Pop" collection, which brought fashion and popular culture together in an unprecedented way.

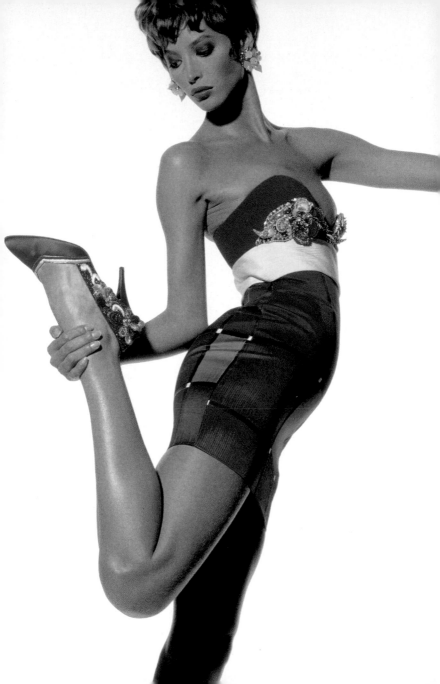

> ## "I think that's the key to my fashion, the contrast between the rich and the poor, the crazy and the sophisticated."
> ### – Gianni Versace

OPPOSITE Gianni's unapologetic love of colour took the fashion world by storm. His "Pop" collection in S/S 1991 was bright, tight and short. Here, Christy Turlington poses in silk satin with matching embroidered shoes, photographed by Irving Penn in October 1990.

Musée Jaquemart-André in Paris. But for Spring/Summer 1990 he decided to show at the Ritz, paying $40,000 to cover the swimming pool with a runway, which had to be drained five days prior to the event to ensure there were no traces of chorine. It was a modern and experimental approach to haute couture that would feature short dresses and skirts with lots of colour and detailing. He was "the new kid on the block" of the Parisian couture scene and, in a spirit of joining the gang, one dress displayed an image of the Eiffel Tower and another, the message "Au Revoir à Paris". Versace would now show four womenswear collections every year, two per season: a ready-to-wear and a haute couture collection for Spring/Summer, followed by a ready-to-wear and a couture show for Autumn/Winter.

His headquarters, Palazzo Versace on Via Gesù, had one wing dedicated to fittings for his Atelier Versace couture. Upstairs, 24 skilled seamstresses hand-finished his intricate and bespoke work alongside a team of eight design assistants. Despite the world being in an economic recession and the Gulf War in full force, it was during the early 1990s that Versace became synonymous with sensual desire. His collections revealed lavish opulence, extravagance and luxury through his risqué aesthetic, use of colour, intricate and bold prints, leather and lots of gold: he was the man of the moment, and he appeared to have the Midas touch. Life was to be celebrated: his fashion shows became huge

theatrical events with the best after-show parties to follow, and were eagerly attended by supermodels, A-list celebrities, rock stars and even royalty.

Gianni Versace loved to challenge himself technically and was also daring, which often translated into revealing outfits, through their cut or the fabrics used. He was also a great raconteur who used his clothes to tell stories – stories about people, combining and juxtaposing themes, sometimes extreme opposites – to make audacious intellectual statements. But, above all, he maintained that his fashion had a message of freedom. His work was sometimes met with criticism: collections were described as vulgar and blasphemous or were criticized for objectifying women, or for dressing them as prostitutes. He divided opinions among fashionistas and beyond. But Gianni was always moving ahead, declaring his love for his art and gently disagreeing with his adversaries, including rival Giorgio Armani, with whom he had an ongoing dispute – which Anna Wintour, editor of *Vogue*, famously encapsulated by saying, "Versace dresses the mistress, Armani dresses the wife."

His Spring/Summer 1991 show, the "Pop" collection, was a work of art that merged his love of both classical and pop art (high and low) using fabric as his medium and the garments as his canvas. It was a rich, bold and colourful show: his dresses, jackets and figure-hugging leggings and catsuits featured bright, timeless prints including Andy Warhol's *Marilyn Monroe* and *James Dean* – Versace worked with the Andy Warhol Foundation on the designs, paving the way for future designers. He also presented a print showing *Vogue* covers, reinforcing his relationship with the media and paying homage – and giving a personal nod – to the magazine. He agreed with Anna Wintour that all proceeds from the sales of those pieces would be donated to AIDS research. Girls walked down the catwalk in single file

OPPOSITE Gianni Versace worked in close collaboration with the Andy Warhol Foundation to create the artist's iconic prints of James Dean and Marilyn Monroe, which featured in Versace's "Pop" collection. The latter is displayed here, on a jacket with rhinestone-encrusted buttons.

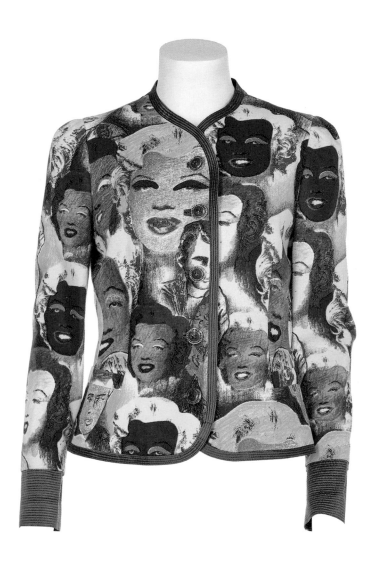

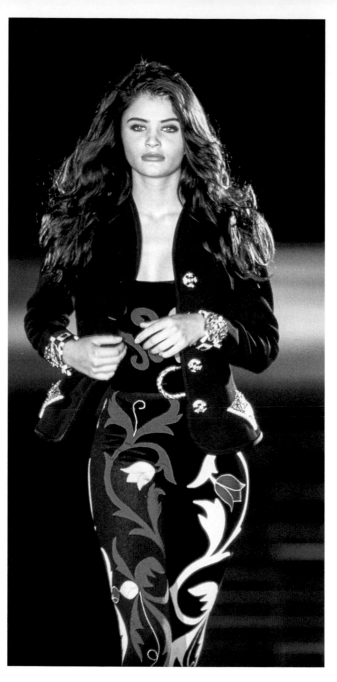

LEFT Versace's A/W 1991 show was a triumph. This figure-hugging, empowering look featured a strong print worn with a fitted cropped jacket.

OPPOSITE Christy Turlington wearing a beaded bolero jacket and matching bra featuring classical Roman designs from the A/W 1991 collection.

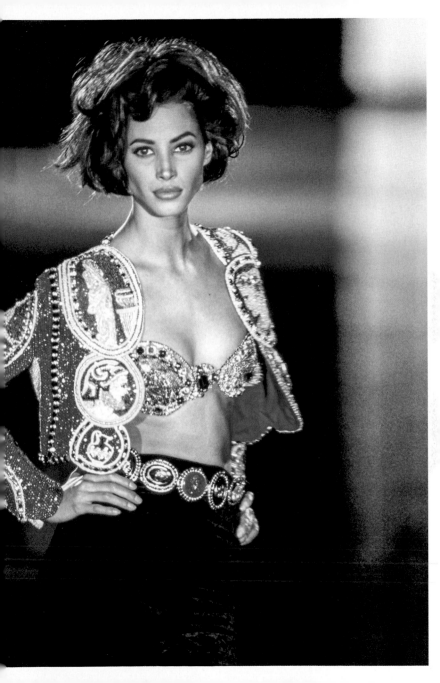

and in groups of three and six, power-dressed in Versace looks: jackets with leggings in bright colours including yellow, lime green, purple, orange, pink and fuchsia. Shorts and short dresses and skirts echoed the swinging 1960s pop-art culture, and his evening wear was opulently embellished with showstopping, intricate jewel detailing. Baroque detailing on prints and beading was merged seamlessly with modern art to create a quintessential and unforgettable collection. A star-studded AIDS benefit fundraiser took place soon after, featuring many of the looks from his "Pop" collection.

His following show, Autumn/Winter 1991, has been described by many as the moment that defined the concept of the supermodel "who wouldn't get out of bed for less than $10,000". In the show, Linda Evangelista, Naomi Campbell, Christy Turlington, and Cindy Crawford, who had recently featured in George Michael's music video for the song "Freedom! '90", were to walk down lip-synching to the song, arm in arm, in short, empire-waisted baby-doll dresses. This snapshot moment in fashion history was an instant success that captured the spirit of the times, bringing together pop music and fashion and – with the rapid rise of MTV television. It was the start of an era of renewed popular culture, full of energy and confidence, and the models became its powerful poster girls. Versace's campaign for that season cast the "holy trinity" – Linda Evangelista, Christy Turlington and Helena Christensen – and was shot by the eminent Richard Avedon.

The collection included a number of short skirts and dresses worn with thigh-high boots, reminiscent of the recent movie *Pretty Woman* (1990), starring Julia Roberts. There was a lot of black, sometimes combined with primary colour blocking. It also displayed a myriad of baroque prints, mostly in gold tones, that had become synonymous with the brand. His evening wear was

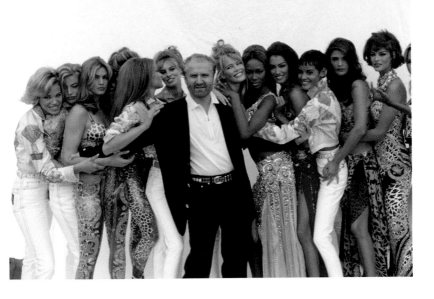

ABOVE Gianni
Versace with a group
of models wearing
his S/S collection in
Milan, March 1991.

another triumph: alongside floor-length, provocative classics, it showcased beaded and embroidered hand-finished pieces (such as bolero jackets, dresses and bodices) with classic Roman and opera themes, bringing high and low, classic and pop, seamlessly together again. The Atelier collection that followed developed the same themes of decorative borders and patterns and included the silver dress with gold detailing that was worn in 1991 by Diana, Princess of Wales, for a portrait by Patrick Demarchelier, which later featured on the cover of *Harper's Bazaar* in November 1997, following her sad and sudden death.

As mentioned, Gianni Versace loved to tell a story, and he described his Spring/Summer 1992 show as a modern romantic

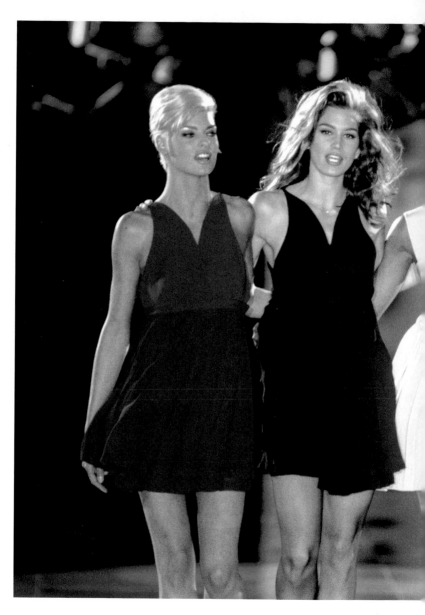

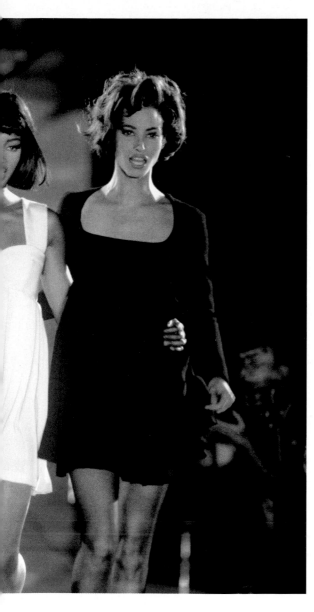

LEFT The moment
that defined the
supermodels, as
they walked arm in
arm, lip-syncing to
George Michael's
"Freedom! '90" in
the A/W 1991 show.

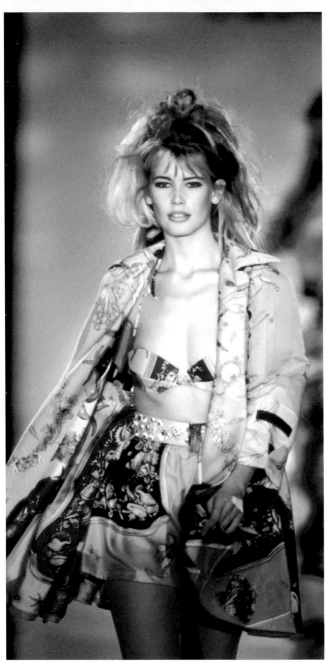

LEFT Gianni loved silk and was meticulous in his design process, through which he achieved exquisite prints that sometimes combined up to 23 colours, as in this outfit for S/S 1992.

OPPOSITE Versace's ability to remain modern was key to his success. This sexy, tight-fitting S/S 1992 look was created with a dramatic and classic baroque print, which has since become synonymous with his aesthetic.

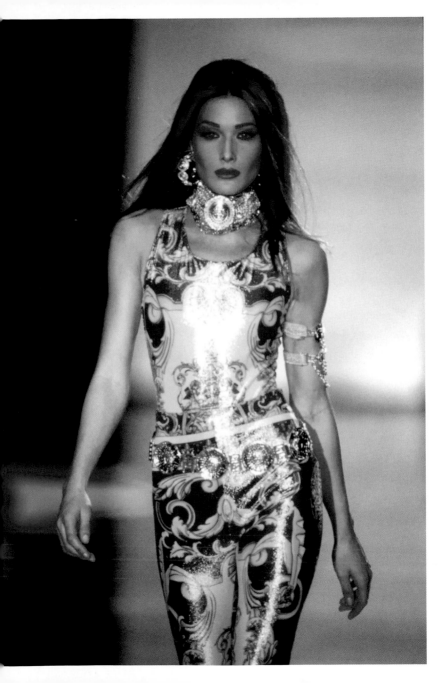

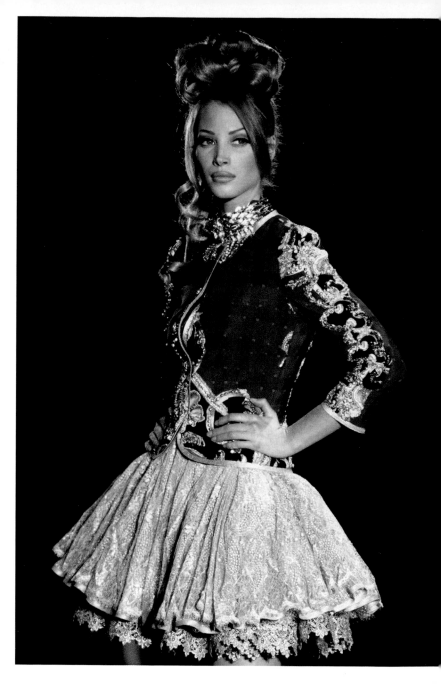

collection drawing inspiration from eighteenth-century rococo artists. Echoing Jean-Honoré Fragonard's painting *The Swing*, it opened with 15-year-old model Milla Jovovich perched on the edge of a swing decorated with flowers. Looks included short, structured, full dresses, and pastel-coloured suits and leggings in exquisite prints (this collection is sometimes called his "Print" collection). Here, he introduced baroque patterns in pastel colours and gold tones, animal prints and a Trésor de la Mer theme. There was also a variety of silk patterns on scarf dresses and shirts, and notably on floor-length ballgown pannier skirts – à la Marie Antoinette – unexpectedly worn with American-style denim shirts, a look he dubbed "romantic rock" or "chic or shock". From daywear through to elegant evening gowns, at times blurring the two, this collection consolidated his hallmark style, empowering women by dressing them with confidence. The collection's campaign included some of Gianni Versace's most memorable images, featuring Linda Evangelista shot by Irving Penn.

"Miss S&M", also known as Versace's bondage show for Autumn/Winter 1992, was another collection that would shake the fashion world, not only for the brilliance of his couture techniques but also for the contentious themes it portrayed. The show began with structured black leather dresses, strikingly feminine with their full 1950s-style padded skirts. These were followed by figure-hugging dresses in pastel colours with deconstructed necklines – as if cut out in geometrical shapes. There was also an American theme, even a cowboy hat, but what caught everyone's eyes were his S&M outfits, so beautifully constructed with soft leather, the finest silk and beautiful gold buckles, that they were both stunning and controversial in equal measure. This show opened a debate about the objectification of women and potential vulgarity of Versace's style, a debate on whether the designer's clothes restrained or emancipated

OPPOSITE Versace's attention to detail and love of embroidery is exemplified in this Atelier S/S 1992 look: a short fitted jacket paired with a contrasting layered ballerina skirt.

women, dividing opinions. On this matter, fashion editor Suzy Menkes notably said she didn't want to see women as sex objects, although they had the right to choose. But Gianni Versace was unafraid to create provocative sexual and fetishistic references, even at the height of the AIDS epidemic. Furthermore, there was a sense of voyeurism about his work that created a distance between the subject and the observer. Notwithstanding criticism of it, the collection was extremely successful and conquered the AIDS benefit gala and subsequent red-carpet events – despite the fact that, according to *Vogue*, it required eight hands for anyone to get strapped into the garments.

While grunge, androgyny and the withdrawn "heroin chic" look were gaining momentum in the fashion background, Versace's glossy womanly aesthetic stood the test of time. His own interpretation of grunge was sophisticated, and perhaps the closest he got to it was in his Spring/Summer 1994 show. This was Versace's "Punk" collection, where he took inspiration from the street, and is best known for "that dress" worn by actress Elizabeth Hurley when she attended the premiere of *Four Weddings and a Funeral* with Hugh Grant. The dress was spectacular: barely-there black fabric panels slashed at the front, with gold oversized safety pins displaying the Medusa logo strategically holding it together. It made the front page of every tabloid and broadsheet and turned Hurley into an international superstar overnight. In true Versace style, the collection was a glamorous interpretation of a theme. Here, British punk culture was explored through mini kilts and lace, slashed fabrics, gold safety pins (always with the Medusa logo) and chain detailing. He also presented micro miniskirts, not just in black but in a broad colour palette that included white, pastels and primary colours. Flat shoes and socks, with simple gelled-down hair and plain make-up, completed his take on this 1990s aesthetic.

OPPOSITE Models Naomi Campbell and Carla Bruni pose in baroque-print outfits with Gianni Versace at The Rhythm of Life Fashion Ball, in aid of the Rainforest Foundation, Grosvenor House Hotel, London, in May 1992. The event was hosted by rainforest campaigners Sting and Trudie Styler.

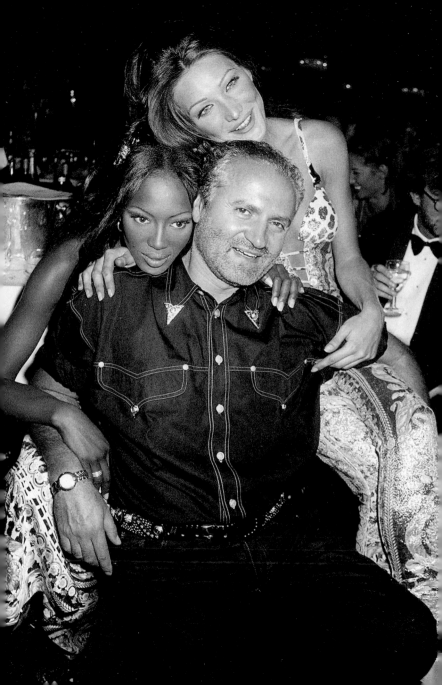

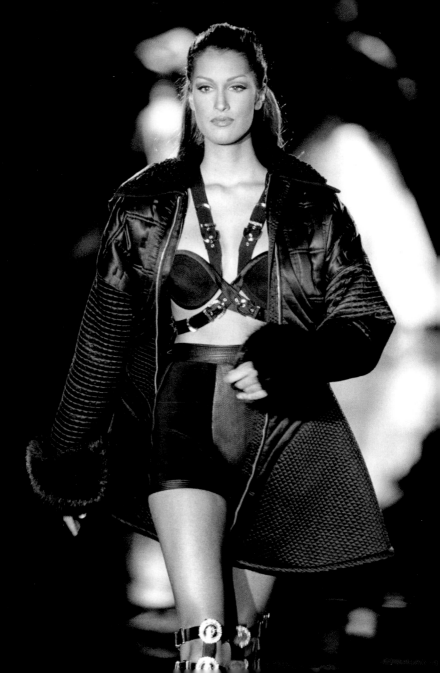

Following this collection, the fashion pendulum returned to glamour, leaving deconstructed shapes and experimental grunge safely behind. The bright signature spotlights that Versace used in his fashion shows were particularly suited to this Spring/Summer 1995 presentation, which was all about classic Hollywood beauty, with Linda Evangelista echoing Marilyn Monroe's platinum-blonde pin curls. Butterfly and ladybird prints, wasp waists and corsets teamed up with full knickers, swimwear and towelling dressing gowns worn with high heels and accompanied by some extra-large tote bags for the perfect poolside chic. He also featured hourglass pencil suits reminiscent of early Pan Am air hostesses and, as ever, exquisite evening wear, showing the influence of Karl Lagerfeld. Draping was evocative of Parisian interwar haute couturiers: Madame Grès's drapery precision and Madeleine Vionnet's bias cut. Madonna was the campaign face for this particular collection, featuring mostly black and white images shot by Steven Meisel at Mar-a-Lago, the Palm Beach estate owned by Donald Trump (where he famously offered them a bucket of KFC).

The Spring/Summer 1995 Versace Haute Couture collection that followed was minimal in its shapes and very Jackie O: elegant and feminine suits were accessorized with satin gloves and clutch bags. For evening wear, it featured spectacular long gowns in simple shapes and pastel colours with intricate pleating and waterfall draping, as well as beading detailing on silk and shimmery satin.

Prince wrote and recorded *The Versace Experience*, a soundtrack to Versace's Haute Couture show in Autumn/Winter 1995. The mixtape, containing tracks that were not released to the general public until 2019, was given exclusively to the guests. Madonna flew in by private jet especially to watch the show, which took a futuristic stance, leaving the intricate baroque

OPPOSITE High gladiator sandals and a bondage-inspired look are worn with a sculpted black leather coat, which is delicately padded and detailed with fur trim on the cuffs, for the presentation of the A/W 1992 collection.

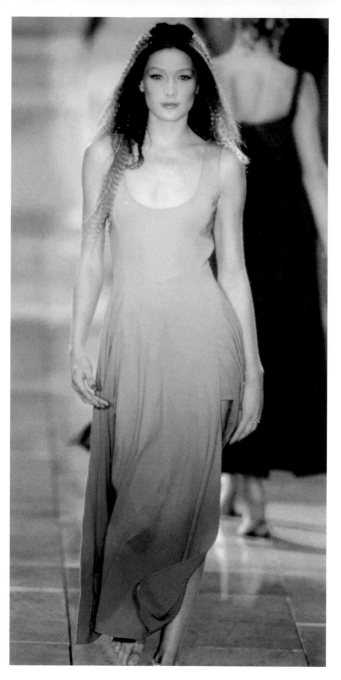

LEFT S/S 1993 emphasized a fresh aesthetic, opening with barefoot models wearing natural-looking, sun-kissed make-up and uncharacteristic bohemian-style loose hair.

OPPOSITE Gianni Versace on stage at the show for the S/S 1994 collection, which showcased his interpretation of punk – with strategically slashed garments held together with golden safety pins featuring Medusa heads.

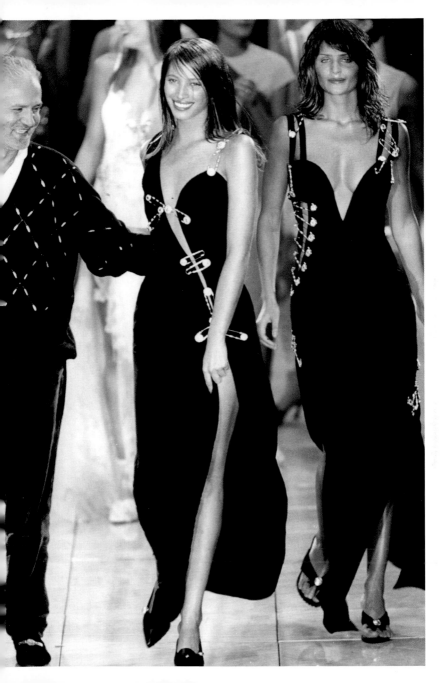

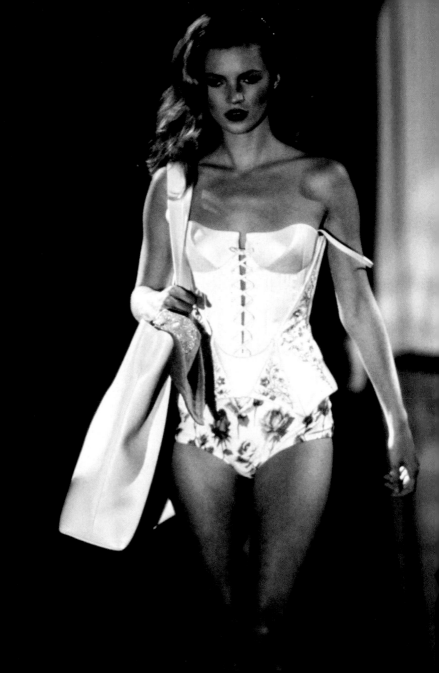

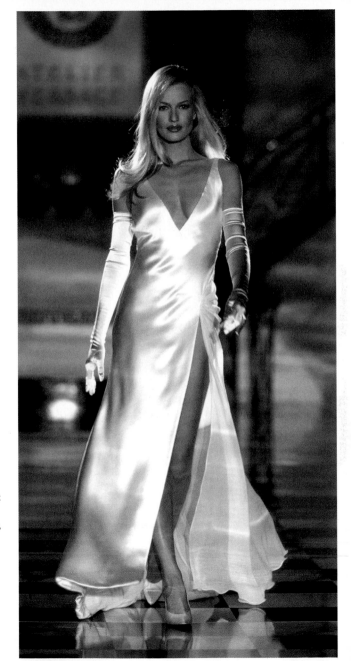

RIGHT Karen Mulder wearing a timeless, floor-length white satin dress and long gloves from the Atelier S/S 1995 collection.

OPPOSITE Kate Moss modelling an exquisite white corset with high-waisted rose-patterned briefs, accessorized with an oversized bag, all from Versace's S/S 1995 ready-to-wear Hollywood-inspired collection.

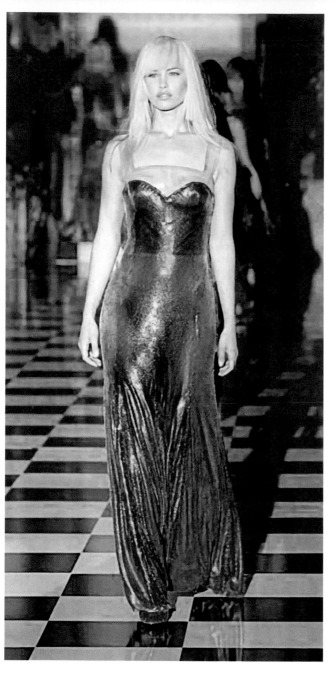

LEFT Versace's Atelier A/W 1995 collection – shown at the Ritz in Paris – was groundbreaking in Gianni's use of plastic to create a futuristic look. The show was attended by Madonna, her chihuahua, her boyfriend and six bodyguards, among other celebrities.

OPPOSITE The Atelier A/W 1995 show closed with Kate Moss as a futuristic bride wearing a hand-applied, crystal-studded short shift dress, a floor-length veil and long white go-go boots.

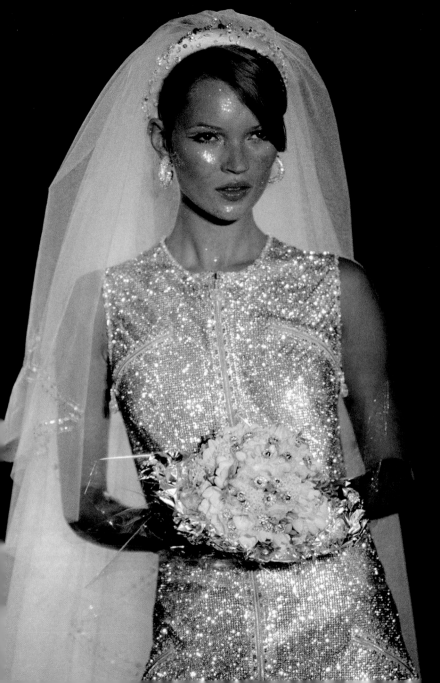

themes behind. It explored the concept of plastic couture, using zips or safety pins throughout instead of buttons, and a technique called thermofusion to make a synthetic mother-of-pearl laminate fit for purpose. The show was primarily white and silver, but after Kate Moss walked down to close the show as a stunning space-age bride (wearing a sparkly white 1960s-inspired shift minidress with a floor-length veil and long white boots) the lights were dimmed, and the girls returned with red dresses under scarlet lighting representing the flames of the Inferno. Angels and demons or heaven and hell?

In contrast, Versace's Spring/Summer 1996 show had a softness about it. He used fabrics such as chiffon, Oroton, organza, premium leather, and lace, mostly plain or with little pattern on it, such as the scribbled prints that made the cover of *Vogue*. For his daywear, there were lots of simple dresses, some with straps, some with short sleeves, as well as suits (skirt and trouser) sometimes showing the belly button. Vibrant citrus colours were used to create head-to-toe monochrome looks with matching shoes and sunglasses – in striking bright orange, lime and yellow, colours also used for his evening pieces. There were also some sheer black or white embellished dresses with bodysuits worn underneath, and colourful mesh dresses.

This simpler, minimal approach continued in his Autumn/ Winter 1996 show, in a bright collection that included suits, coats, skirts and dresses but, more importantly, explored unusual colour combinations, such as pale blue with red, and techniques such as ombre and colour blocked geometrical shapes. He also embellished leather with lace, mesh and rhinestones, as his hallmark of luxury.

By 1997, the Versace Group was worth $1 billion. His chameleonic ability to read the public's temperature and to reinvent himself meant that he was always modern – never

OPPOSITE The Atelier A/W 1996 collection explored asymmetric shapes and art influences. This dress, modelled by Kate Moss, has a fluidity reminiscent of art deco.

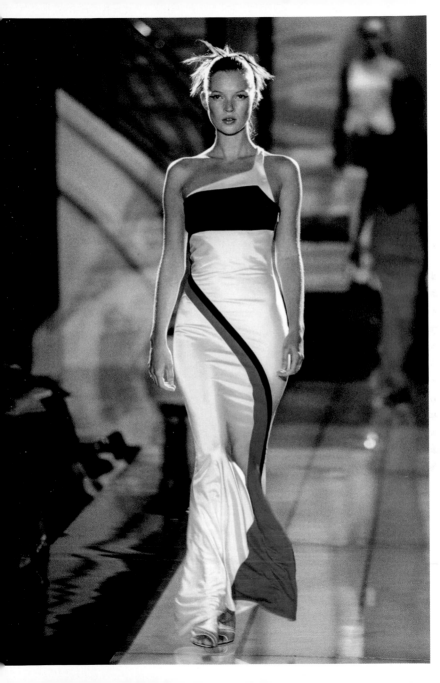

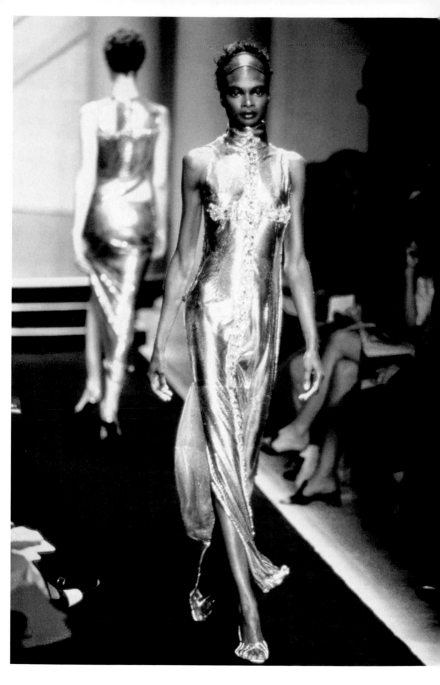

dated – and kept his audience and clientele on tenterhooks, wondering what he would come up with next. His Spring/ Summer 1997 show was all about art. Bohemian models wore flowers in their hair and the collection featured some beautifully delicate translucent fabrics, viscose knits and kimonos. He also included some unusual prints, which were inspired by artists such as Julian Schnabel and Peter Schuyff, from whom he'd recently acquired pieces for his New York residence. Atelier Spring/Summer 1997 developed the art theme further, in a rich spectacle that comprised different styles. It opened with a number of simple black dresses, many shoulderless and some with a fishtail-hem trim, worn with a black lace blindfold. Red dresses followed, and then some Latin-inspired outfits in red and black, styled with a neckerchief. Stunning prints were explored towards the end, echoing the work of Calder, Picasso and Matisse. As is traditional in a haute couture show, to finish, the show featured the obligatory bride, wearing a white shirt and a white belted pencil skirt with ruffled ends. She wore an embellished Spanish comb holding her lace veil in place, while she held a bunch of blood-red roses.

Gianni Versace's Haute Couture "Byzantium" collection (Autumn/Winter 1997) took place at the Ritz in Paris. It has become a highly significant show because it was to be his last, but also, perhaps, because he'd recently recovered form a rare form of cancer. It embraced a new direction: Versace minimalism. As is often the case, the Atelier collection was an extension of his previously shown ready-to-wear looks, focusing on a theme and exploring it in depth. His ready-to-wear collection sported a modern, minimalistic silhouette that was clean and linear, using colour block instead of patterns, and was modelled by fresh-faced girls with updos and

OPPOSITE Gianni Versace pioneered the introduction of the symbol of the cross to the runway. Here, a floor-length Oroton dress from A/W 1997 is embellished with a large Byzantine cross over the entire front of the garment.

ponytails. It was a collection that could have stepped straight into the street and, although much quieter than previous work, was just as strong. In keeping with this linear simplicity, his Atelier collection featured religious cross motifs throughout, inspired by an exhibition he'd seen at the Metropolitan Museum of Art in New York, and perhaps also remembering his mother, who would always cross herself before sewing. The show opened with classic tailoring in a pinstripe fabric – trouser suits, dresses and skirts, followed by a lot of black with sculpted shoulders and some with asymmetric shapes that added a futuristic twist. The models wore heavy, dark eye make-up and red lipstick, their hair pulled back under thick leather Alice bands, echoing a Goth aesthetic. Longer dresses followed, with deconstructed detailing and some sublime, classic pieces that were reminiscent of John Galliano's work. Dresses embellished with leather and Oroton – some short and some floor-length, in gold – finished the collection. For the bridal-gown finale, Naomi Campbell wore a very short metal-mesh studded gown in silver with a cross embroidered on the veil. Nine days later, Gianni Versace was shot dead outside his Miami mansion as he was returning from a walk. His death would close a chapter prematurely and leave a permanent mark on the fashion world.

Italy mourned Gianni Versace's death with an emotional "Tribute" collection, which took place on 11 September 1997 on Rome's Spanish Steps. It included some of his key looks as well as the works of other designers, such as Valentino, to the soundtrack of The Police's "Every Breath You Take", as requested by his family, who didn't attend. There was also a staged memorial event at The Met's Temple of Dendur. At his funeral – attended by a devastated Diana, Princess of Wales; Elton John; Sting; and Georgio Armani, among many other friends – the mood was dark: it was the end of an era.

OPPOSITE Gianni Versace's last appearance on the catwalk took place during his Atelier A/W show in 1997. Here, he greets Naomi Campbell as she closes the show (instead of Karen Elson, who was originally slated to do so) in a silver Oroton mini bridal dress embellished with crosses, and a veil with a cross on the back.

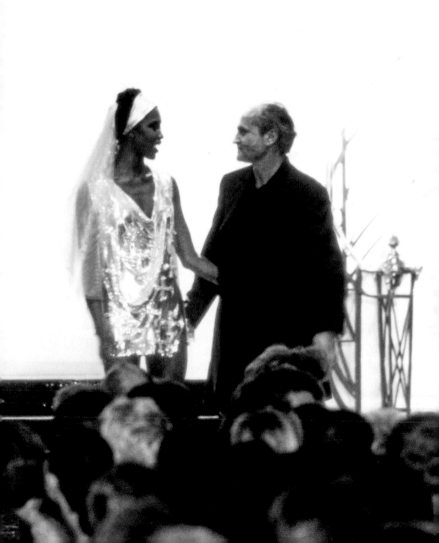

THE HOUSE
OF VERSACE

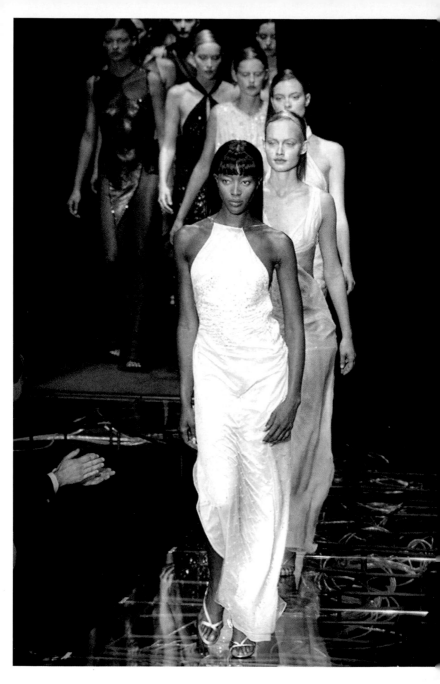

THE DONATELLA YEARS

"When my brother died, and the way he died, I had to show strength. I had to show 'We're going to do it. Don't worry.'" – Donatella Versace

Despite being eight years her senior, Gianni Versace and his sister Donatella had an incredibly close bond. It was he who persuaded her to dye her hair blonde when she was just 11 years old, inspired by Italian pop singer Patty Pravo. "I was his doll and his best friend. He dressed me up in cool clothes, took me out to discos and clubs from when I was 11. I loved it. It was the best time of my life," Donatella recalled. Throughout the 1990s, she was his right-hand woman. She supported him with his collections, working as his advertising image director and always offering a female perspective and daring him to go sexier, bolder or shorter. He trusted Donatella, treated her as his first customer and described her as a very strong woman, a mother and a friend of all the rock stars.

OPPOSITE S/S 1998 marked the start of a new chapter for the House of Versace. Donatella's collection presented asymmetric shapes and deconstructed garments and, despite mixed reviews, was received with warmth by the press overall.

Then, overnight, with Gianni's sudden departure, his elder brother Santo became CEO of the company – and Donatella, who had been responsible for diffusion line Versus since 1989, took over as head of design. She took the dynasty's reins and decided that the show had to go on. Giving up was never an option. Understandably, it took her some time, but after an unsettled start, she was ready to step into the role, stamping her mark on the Versace brand and incorporating a feminist stance.

"I like clothes to make women feel powerful."

– Donatella Versace

The House of Versace's first collection after Gianni's death took place barely three months later, in Spring/Summer 1998. It was shown at the usual venue, the courtyard of Via Gesù in Milan. In the audience, Gianni's fashion cohort – names such as Donna Karan, Giorgio Armani, Angela Missoni, Miuccia Prada, as well as his master Karl Lagerfeld – offered quiet support. And sitting in the front row were Cher, Boy George and Demi Moore. A neon sign read:

"This show is dedicated to our brother Gianni's love of work and to our entire staff, whose incredible love and devotion was so precious to our brother and means so much to us. We thank each and every one of them."

After this, the models walked out to Madonna's (soon-to-be-released) song "Candy Perfume Girl", with Kate Moss and Naomi Campbell leading and closing the procession. It was

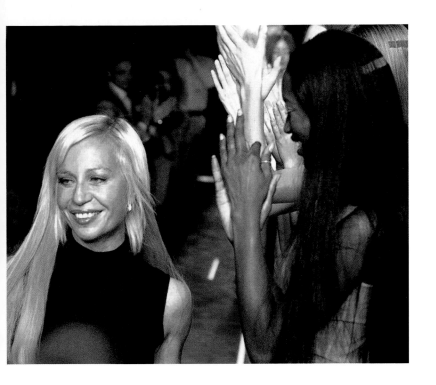

ABOVE Donatella's
first Versace
show, S/S 1998,
took place shortly
after Gianni's
sudden death. Her
collection was clean
and elegant, and
explored different
fabrics, such as
leather, plastic and
chiffon.

a quiet presentation with clean, elegant lines. It showcased dresses and trouser suits in leather, chiffon and Prince of Wales check with slashed, deconstructed, asymmetric shapes, as well as floral dresses on models wearing slicked-back hair and berry-coloured lips. Chiffon gowns with beading in the shape of constellations, and a pink print with blue stars on it, suggested the night sky – and perhaps heaven and beyond.

Donatella's debut haute couture collection, a year and three days after her brother's death, took place, as it had always done, in the Ritz Hotel in Paris, with the runway laid over the swimming pool. This time, however, the runway was made of sheer glass. There was something futuristic about the shapes and

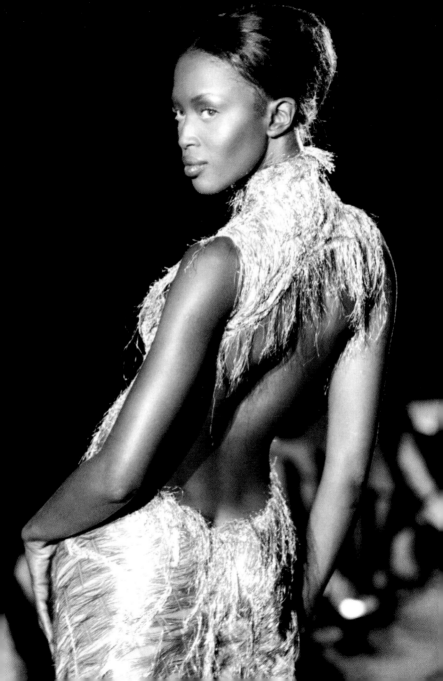

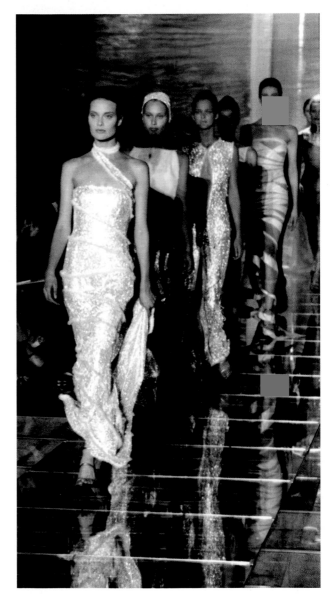

RIGHT Donatella's first Atelier collection was the A/W 1998 show, which once again took place in the Ritz in Paris, with the models walking on a catwalk made of sheer glass, adding to the futuristic feel of the collection.

OPPOSITE Naomi Campbell wearing a silver backless halterneck gown with rough fringing detail for A/W 1998.

necklines in particular – polo-neck dresses and sightly raised funnel necks – which received mixed reviews. She chose muted colourways as well as black and red, and combined many frayed edges with slicker, sharper finishes. There were cut-outs and slashes, and some outfits had completely different lengths at the front and back, as if they did not belong together. Donatella also presented pencil skirts with matching zipped jackets, and some unusual accessories including arm-warmers and bonnets that looked like swimming caps. The show ended with floor-length, figure-hugging, sheer, sexy gowns that sparkled on beautiful models who seemed to glide with their hair pulled back and barely-there make-up. It was closed by Naomi Campbell, wearing a silver-embellished, polo-neck, backless dress. This time there was no bride.

Another turning point for Versace was Spring/Summer 2000, a strong collection in which tropical prints – in green and orange jungle patterns – took centre stage. It featured halter-neck tops and dresses revealing shoulders, necklines plunged to the navel, racy swimwear and sexy suits. Amber Valletta modelled the low-cut, green silk-chiffon jungle dress, studded with citrine stones, that was later worn by Jennifer Lopez at the 2000 Grammy Awards ceremony. So many people searched for the dress online (it was the most popular Internet search ever) that it made history by prompting Google to launch the Google Images search function.

Many narratives were given over the collections that followed, including stories of glamour, medieval influences, goth, punk and rococo. But there was a marked shift in the Versace aesthetic from the Spring/Summer 2005 collection onwards, coinciding with Donatella's recovery from addiction: a shift that showed a new-found confidence and focus in her work. And it was here to stay.

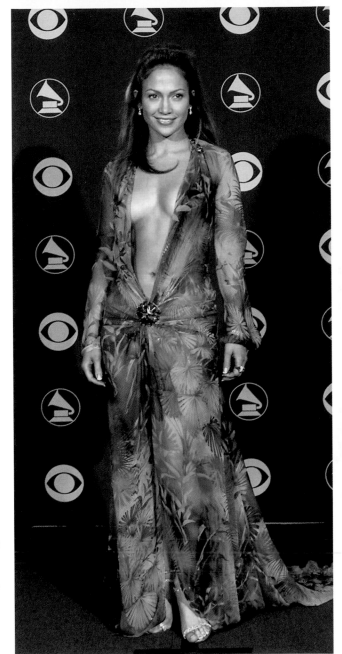

RIGHT Jennifer Lopez in Versace's show-stopping green jungle dress at the Grammy Awards held in Los Angeles in February 2000. So many people searched the internet to find it that it prompted the creation of Google Images.

RIGHT The S/S 2014 collection was described by the Versace team as evoking "the elegance and power of the contemporary goddess".

OPPOSITE The S/S 2014 show opened with the song "Donatella" by Lady Gaga, who had featured in the Versace S/S campaign that year. Elegant headdresses reminiscent of Grace Jones's style appeared throughout the show.

Spring/Summer 2005's show was sexy, compelling and wearable. This was a collection for real, sophisticated women – as reflected in Mario Testino's advertising campaign, featuring a platinum, Marilyn Monroe-esque Madonna "at work" in a streamlined, minimal white office, where she's seen on the phone, propping her high-heel-clad feet on her glass desk, or licking an envelope closed. It brought together classic tailoring and silk designs (including the iconic starfish and coral print), swimwear and terry towelling robes, as well as sexy day shirt-dresses and evening wear with sophisticated draping and low necklines. Natural sun-kissed make-up highlighted glowing skin, and the right amount of gold accessories completed the look. The following season, Autumn/Winter 2005, took a more scaled-back approach and was all about the silhouette, with Donatella opting for monochrome looks in mostly white and black with some looks in lime green, turquoise and hot pink. The show finished with some sheer, beaded floor-length Atelier looks that were no longer being shown at Fashion Week. It was a timeless and alluring collection that stripped down Versace to its essence and reinforced its position on the fashion stage.

Donatella's work wasn't overlooked, and she received a series of major awards in the years that followed. In 2010, she won the Glamour Woman of the Year Award in New York, and in 2017, the British Fashion Council's Fashion Icon Award at the Royal Albert Hall in London "for her determination and persistence to maintain the brand her brother created". A year later, in 2018, she was awarded the International Award by the CFDA (Council of Fashion Designers of America), which celebrated her singular vision.

Versace's "Tribute" collection for Spring/Summer 2018 has been termed the most memorable fashion show to date. It marked the 20-year anniversary of Gianni's death, and as such, was a celebration of his work and life – a walk down memory lane,

OPPOSITE To mark the twentieth anniversary of her brother Gianni's death, Donatella's S/S 2018 show was a "tribute" collection, featuring some of his best-loved prints.

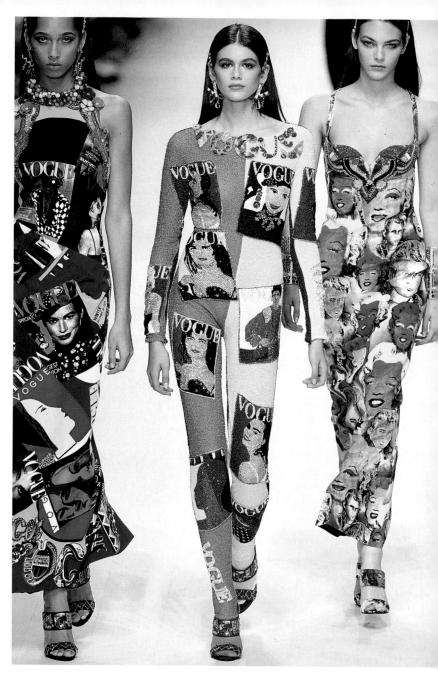

fittingly shown at Milan's Triennale museum. Donatella was ready to tell the Gianni Versace story to new generations: in Donatella's words, "how in love he was with his work", his redefinition of fashion, his courage and bravery, and his passion for empowering women. She, herself, found the courage to go back into his archive and resurrect and rework many iconic looks. One in particular (a black and white skirt originally worn by Naomi Campbell in Autumn/Winter 1992) was so detailed that it couldn't be replicated in time for the show: around 35,000 small strips covered in organza had been sewn together to make the skirt, and this would have taken around six months to complete, so the original garment was worn again, this time by model Natasha Poly. The show opened in Gianni style, with a group of models in rococo prints, followed by some pieces from his Autumn/Winter 1992 collection. A female voice-over (Inês Coutinho AKA DJ Violet) said: "This is a celebration of a genius, this is a celebration of an icon, this is a celebration of my brother."

There were soft pastels on structured, tailored pieces, and more classic prints, this time showcasing the butterfly and the Trésor de la Mer prints. There was, of course, a Pop tribute section featuring the iconic Spring/Summer 1991 Warhol prints, with models again walking as a group (Kaia Gerber, Cindy Crawford's daughter, was modelling an embroidered jumpsuit with the Vogue cover print that included an image of her mother). Finally, there were religious crosses reminiscent of his last Byzantine collection. The audience clapped, assuming the show had ended. Then, as soon as the last model had walked off, the music faded and a DJ announced: "Gianni, this is for you." The back curtain opened up to reveal Gianni's "original" models: Helena Christensen, Cindy Crawford, Naomi Campbell, Claudia Schiffer and Carla Bruni, standing side by side and on podiums, in long dresses made of gold metal mesh. The result was electrifying, and the crowd

OPPOSITE The "Pop" styles from Gianni's S/S 1991 collection were revisited in Donatella's S/S 2018 "Tribute" show. Here, Kaia Gerber wears a print featuring her mother, Cindy Crawford.

erupted in an emotional accolade. In Donatella's words, "Gianni created the supermodel, so what better finale than to try to give this tribute to Gianni, to take these supermodels and put them on the runway as a surprise."

The momentum remained and the mood was high for Autumn/Winter 2018, in a show that juxtaposed many identities, ideas, themes and patterns alike. Donatella called it "the family of Versace ... a lot of women coming together to be courageous and strong".

The girls looked positively cool: there was bright tartan – in red, yellow and electric-blue colour combinations, hinting at punk roots – branded scarves, flat caps and Versace-logo football scarves and T-shirts. Denim, plaid dresses and leather looks were accessorized with big-buckled belts, and fitted black corsets were worn over colour-clashed vibrant prints and Versace-logo T-shirts, or teamed with dresses and ballgown-style skirts. There were also some headscarves and sunglasses that added glamour and reinforced Versace's cultural inclusivity.

For Spring/Summer 2019 there was, once again, a "more is more" approach, with clashing prints and bursts of colour (orange, neon yellow, shades of cyan blue and mint green). The intergenerational model-casting concept that was so successful in the Tribute collection was back when supermodel Shalom Harlow (then 44 years old) closed the show. What perhaps marked the show's presentation was a fusion between casual and formalwear – model Bella Hadid wearing trainers with a neon-yellow leather dress – that made the look, and the brand, more accessible to a wider demographic. Bright stripes, checks and delicate floral prints, on dresses, separates, trousers and headscarves, were skilfully layered. They were put together and accessorized playfully, alongside classic black satin slit dresses that were sublime and timeless in equal measure.

OPPOSITE Two models walk in thigh-high boots with leather crosses on them, echoing Gianni's love of Byzantine art, in the S/S 2018 show.

NEXT PAGE Steven Meisel captured the timeless essence of the Versace brand in the S/S 2018 advertising campaign: the ever-present Medusa head, animal prints, leather and gold Oroton.

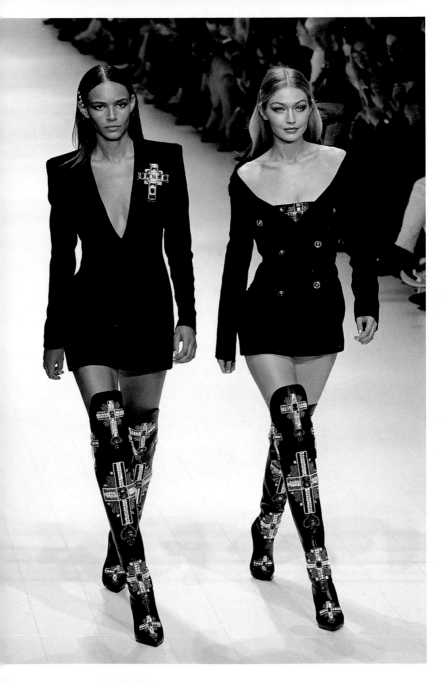

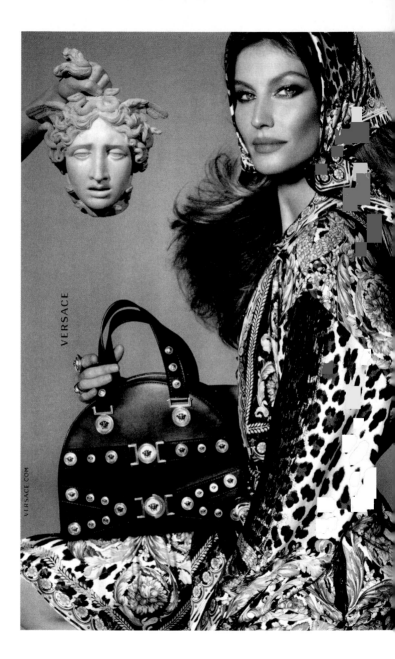

VERSACE

VERSACE.COM

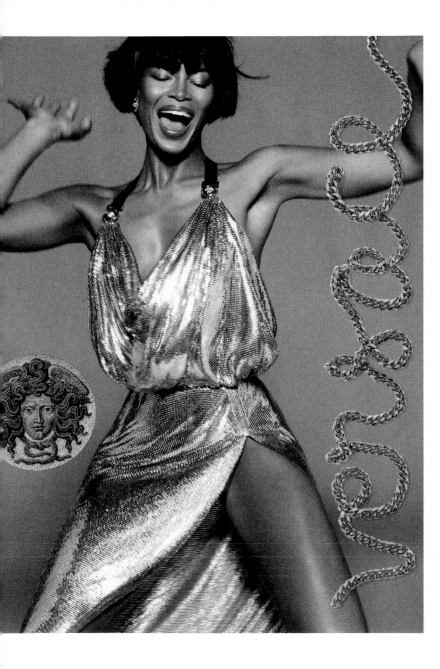

> ## "Anything about technology, change and innovation ignites my creativity ...!"
>
> ## – Donatella Versace

Autumn/Winter 2019 told a story of imperfection, which Donatella depicted through the grunge aesthetic of the 1990s, creating an alluring alternative narrative. "Today we live with Instagram, we want to be perfect all the time. I think it's time to stop for a while and think again. A little bit of imperfection is the new perfection," she told the press before the presentation. This was also her first collection since the $2.1 billion Capri Holdings takeover, and there was a sense of anticipation: would it still be Versace as we knew it? The answer was a resounding yes: the Versace DNA proved to be stronger than ever. As if to make this point, there was a huge gold safety pin with the Medusa head logo – like the ones on "that dress" of Elizabeth Hurley's – arched over the runway. Beanie hats also featured, as well as a black and white T-shirt printed with a shot of Donatella, which had been taken by Richard Avedon in 1995 for Versace's fragrance Blonde. There were also coats with faux-fur trims – including fuchsia-coloured fur. Donatella also presented branded bags, bondage straps, ruched fabrics and delicate draping, lace detail in stockings, and contrasting bold colours – yellow, pink, lime green, blue and orange. Plenty of handbags in different sizes made an appearance, with a large baroque V as the Versace logo (the new Virtus bag). To close the show, Stephanie Seymour, who had been a favourite Versace model in the 1990s, wore a floor-length, bondage-inspired black dress.

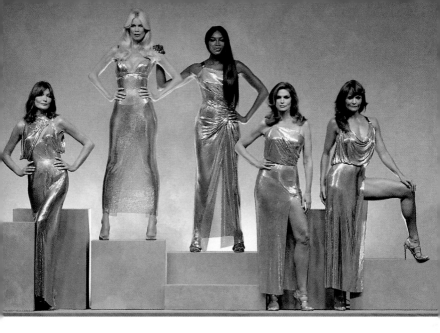

ABOVE The moment "the Supers" (Helena Christensen, Claudia Schiffer, Naomi Campbell, Cindy Crawford and Carla Bruni) were revealed on stage at the S/S 2018 show, wearing Gianni's timeless Oroton dresses.

This renewed Versace energy continued driving the Spring/Summer 2020 collection in a show that played on the role of technology. It marked 20 years since JLo's green jungle dress had caused Google to crash. The presentation had many 1990s influences: clean, sculpted lines with slim, feminine waistlines and volumized skirts, and broad shoulders, denim and pinstriped shirts and tailoring for the city girl. Accents of lime green, orange, and pink and, of course, the jungle print (in both the orange and the green colourways) appeared in trouser suits, dresses, and even on the accessories such as shoes (strappy sandals with smoked Plexiglas heels), jewellery and Virtus bags. Tie-dye T-shirts (and tie-dyed leather) also featured, with the Medusa logo, or Gianni Versace's signature, stamped on them. Donatella has always been instrumental to the emblematic Versace branding process, overseeing the early photo shoots and coordinating celebrities and editorial models with her brother.

Now, her deep understanding of publicity and reinvention was once again present in this collection, embracing new technology: the stage brought together classic features, such as a Pantheon-inspired ceiling and a gold palm tree, with state-of-the-art digital projections. The last model to walk, wearing a stunning black evening dress, was Amber Valletta (who wore the jungle dress in the Spring/Summer 2000 show), after which there was yet more entertainment: Donatella's voice-over was heard asking Google to show her JLo's jungle dress. Immediately, projected on to the wall, images of the singer appeared, wearing it at the Grammys (using Google's latest Tilt Brush technology). Then she asked again to see the *real* dress, and this time, Jennifer Lopez appeared wearing it and walked down the runway to receive a standing ovation. A masterminded moment that, inevitably, went viral.

The following Autumn/Winter show, shown in February 2020, also recounted the relationship between fashion and technology in the digital age, this time with an emphasis on narcissism and the selfie. Before the show began, the walls had virtual images of Donatella projected on them hundreds of times, which then changed to mirror the audience, and later changed to a number of projections, such as graphic black and white patterns, Medusa heads and a large golden Medusa logo. The collection showed men and women's looks together for the first time and, although androgyny didn't feature, there were shared themes, such as athleisure rugby-style tops (the women's were shaped to come in at the waist) and tailoring. It championed both genders. For the men's looks, there were suits with broad shoulders (which had a Sherlock Holmes elegance to them), leather jackets, plenty of branding, casual sportswear and accessories, including bags and chunky, unisex, wellington-style white boots. For the women, looks included camel coats, suits that came in at the waist, Prince of Wales miniskirts and

OPPOSITE S/S 2020 marked 20 years since the last green jungle dress had been worn to the 2000 Grammys by Jennifer Lopez. To celebrate, Donatella created a new sensational look reminiscent of the original, and JLo herself modelled it on the catwalk.

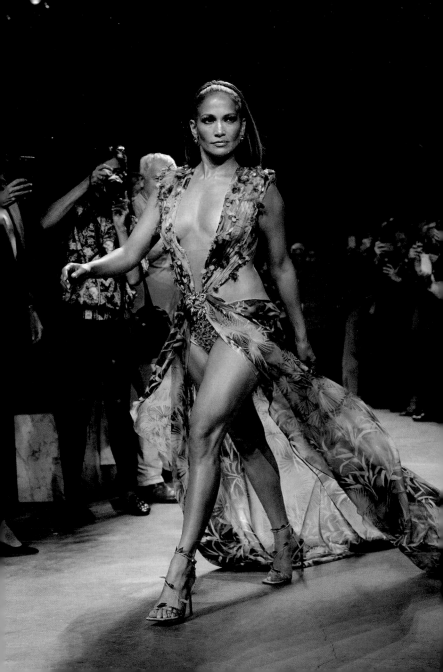

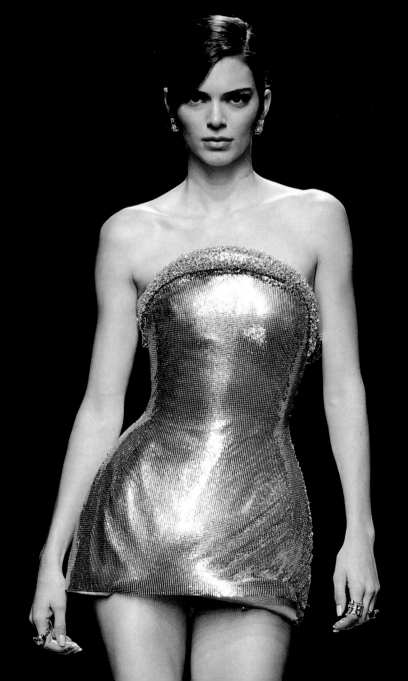

sculpted, hourglass-shaped short dresses. There was a lot of black, but also a black and white print featuring a V for Versace, and other explosive, rich, bright patterns, including a striking neon-pink suit – one for men and one for women – worthy of a rock star. Evening wear closed the show, the highlight of which was a short metal dress reminiscent of Gianni's Oroton gowns – shoulderless, raised at the front in woven intarsia (made of metal and crystal mesh) and worn by model Kendall Jenner.

Life as we knew it stopped in 2020 with the arrival of the Covid-19 pandemic. Donatella spent lockdown alone in Milan with her Jack Russell, Audrey (who has her own Instagram page). There was plenty of time for thinking, for reflection and for reinvention. Donatella has since talked about sustainability – something that was already very much on the agenda. Versace had been actively working on its phasing out of fur from 2019 and of kangaroo leather from 2020. She also talked about the end of throwaway fast fashion and her desire to simplify trends by creating smaller, seasonless collections that could show 30 looks instead of the traditional fashion shows that contain up to 80.

The following Versace presentation, the Spring/Summer 2021 collection, was an upbeat show that, again, combined womenswear and menswear. For the first time, she also introduced some plus-size models in her cast: Jill Kortleve, Alva Claire and Precious Lee. As we all woke up to birdsong and cleaner air, Donatella chose the uncharted ocean as her presentation's backdrop, and a colour palette that reflected the theme: pale blue shades and bright patterns of the colour dissonance found in tropical fish. The silhouettes floated effortlessly, either through the choice of fabric or the cascading cuts – with ruffled skirts, micro-pleating and bell-shaped dresses suggestive of anemones. As is now almost expected of a Versace show, it brought together modern influences such as neoprene,

OPPOSITE Kendall Jenner wearing an evening minidress in woven intarsia, made of metal and crystal mesh, echoing Gianni's love of metal and technical challenges, for the A/W 2020 show.

RIGHT A bright coral Medusa latex minidress is accessorized with a contrasting orange belt and headdress and a pale blue handbag. Platform slip-on sandals in pistachio green complete this S/S 2022 look.

OPPOSITE An explosion of colour was the perfect antidote to Covid-19 lockdowns for S/S 2021, a show that was streamed live and was described by Donatella as having "an upbeat soul".

zipped crop tops and chunky trainers with classic tailoring and vintage Versace prints. This time the focus was on the Trésor de la Mer print, which also served as the inspiration for seashell motifs and necklaces, and was extended to satin crop tops with crystal embroidery, making the girls look like mermaids. The show also incorporated sportswear, and – why not? – with plenty of branding on socks and accessories.

With Italy still in lockdown, Autumn/Winter 2021 was presented in the form of a digital show "in a new way of communicating collections", as stated on the Versace website. The main theme here was the launch of a monogram print called La Greca, reminiscent of Fendi or Louis Vuitton's geometric pattern, representing a new era and identity, and a celebration of the brand's updated DNA. The stage was a multi-level labyrinth in the shape of the print, on which models were seen walking in and out, the camera following them, then cutting to someone else, like bees in a hive. The clothes were classic, some with a 1970s flavour to them – platform shoes and boots, tailoring and brown knits and jackets. But the show was slick and modern, embracing a multicultural inclusivity of styles: bright short looks in plain yellow, magenta and red; logo sportswear; mesh; leather; headscarves; and plenty of black evening wear, including an imposing floor-length sheer skirt. The monogram was everywhere: on knitwear, dresses, coats, trousers, jackets and – of course – in the accessories (some girls were styled with a La Greca bandana over very long straight hair and Cleopatra-inspired eye make-up in colours such as bright pink or turquoise blue, and one male model had the monogram shaved on his head). The show ended with the models walking in line to strike a pose, with plenty of attitude, on the "ground floor" of the labyrinth, and with Donatella presiding over them, next level up.

OPPOSITE For S/S 2022, Donatella colour blocked using bright shades, emphasized by two-toned cat-eye make-up. Here, Versace Medusa-head safety pins in lime green and gold secure a miniskirt.

"[Fashion] is still about dreaming, it's still about putting yourself in another dimension."

– Donatella Versace

The Spring/Summer 2022 show was livestreamed as well as performed. Singer Dua Lipa, the face of the Autumn/Winter 2021 campaign, opened and closed the show in her runway debut. She wore a tailored skirt-suit with cut-outs and signature safety pins – this time in bright colours – and a striking two-piece outfit made of pink metal mesh. The starry cast also included Lourdes Leon (Madonna's daughter), supermodel Naomi Campbell and Precious Lee. It was a bright collection that seemed to be open to new possibilities, merging elegant tailoring with the kaleidoscopic patterns of Versace's iconic silk foulards, now transformed into skimpy tops, dresses, headscarves, short skirts, trousers and shirts – the scarf being the show's main inspiration. Some original Versace prints reappeared, but there were also different colourways added to the recent La Greca Signature line. The girls wore sexy, brightly coloured cat's-eye make-up and mostly slick, straight hair on looks that included deconstructed tailoring held together by safety pins, with dresses and skirts in shiny latex, leather, silk and metal mesh. There was a relaxed sports influence and plenty of accessories – trainers, handbags, shoes – in summery colours such as bright pinks, white, lime green, orange, purple, aubergine, yellow and turquoise. Some rose-tinted glasses and a T-shirt that read "Versace Dream, Via Gesù 12" even made an appearance.

Autumn/Winter 2022 was a confident, sexy show that embraced femininity with an emphasis on corsets, showing Donatella at her best: empowering women and adapting the Versace aesthetic by making it relevant to ever-changing times. It evoked 1980s power

OPPOSITE Singer Dua Lipa, wearing a two-piece pink chainmail look, flirts with the audience in her catwalk debut at the Versace S/S 2022 presentation.

ABOVE Donatella smiles at an appreciative audience on the runway after her S/S 2022 presentation.

OPPOSITE A/W 2022 featured the La Greca monogram print that was launched in Spring/Summer 2022, updating the brand's Greek Key.

dressing, perhaps in response to the recent humdrum "work from home" lockdown fashion. In contrast to the figure-hugging tops and bustiers, midi and miniskirts and lurex leggings, there were other silhouettes, such as wide palazzo trousers and oversized outerwear. Boxy coats in houndstooth and red-check patterns, generous leather jackets and coats, big, shiny, belted puffa jackets and oversized satin topcoats straight from her men's collection, in bright pink and peacock blue, were also showcased. Other colours highlighted in the collection included black and splashes of red, purple, and pea green. The make-up was inconsistent, reinforcing individuality; some girls looked fresh and make-up free while others wore dark red lips and dark eyeshadow. The accessories included platform shoes and boots, and a new wish-list-worthy Greca Goddess line of bags. One T-shirt encapsulated the Versace spirit and its flirtatious nature. It read: "I love you but I've chosen Versace" – because, of course, we all love Versace.

LEFT Imaan Hammam
wearing a Medusa
latex midi dress, with
Medusa detailing on
the straps and zip, for
the S/S 2022 show.

MENSWEAR

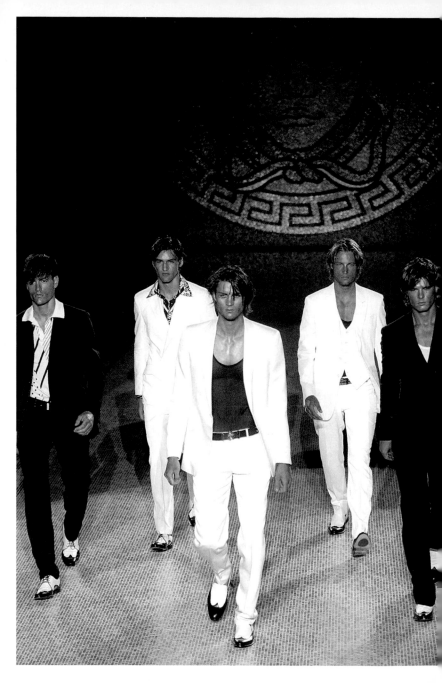

THE VERSACE MAN

**"When I work for fashion it's the same for me,
it's like a drink of fresh water."
– Gianni Versace, on whether he preferred to design
womenswear or menswear (on *Charlie Rose*, 1994)**

Since his very first show, Gianni Versace's menswear has been as influential as his womenswear. Still relevant today, his early work was adventurous and modern and portrayed men with confidence and individualism wearing styles such as off-duty linen suits in pastel colours, or his fine, iconic, printed silk shirts, which are more like blouses. Versace was openly gay, and he himself became a prominent and influential figure among the LGBTQ+ community of his time. His men's advertising campaigns were charged with the assertive energy, conviction and sexuality of his collections, challenging the more traditional concept of menswear. He introduced interesting textures, colour, movement, fantasy and drama into his presentations and, as with his womenswear, brought the arts together to tell a story through his clothes, with the help of campaign photographer Bruce Weber. Today, the archetypal, quintessential Versace look is as recognizable as ever, adapted and reworked by Donatella through updated

OPPOSITE Versace's menswear broke the rules by
dressing down formal tailoring with T-shirts and shirts
with no ties, as seen in these looks from S/S 2006.

tailoring silhouettes. In 2017, she steered the menswear collections away from the classic, traditional male models – reminiscent of Greek gods – that had always been used by Versace, and made them more inclusive and relevant to consumers. Like her late brother, she is always keeping up with the times.

A prominent look in men's fashion was famously encapsulated in the 1980s by the wardrobe on the American TV show *Miami Vice*, which heavily featured Versace clothing. First aired in 1984, this undercover-cop television show impacted menswear worldwide, changing the way men dressed. As Jodie Tillen, the costume designer for the show's first season, said, it opened menswear to the world of colour and comfort. Gianni became a friend of the show, and actor Don Johnson was the first person he dressed in Miami. The main characters had up to eight costume changes per episode: Crockett (Don Johnson) wore Versace pastel-coloured T-shirts under immaculate white linen suits, with no belt or socks (and a three-day stubble), and his counterpart Tubbs (Philip Michael Thomas) opted for sharper, more sartorial clothes. This beach style, or "resort" style, would become one of Versace's timeless signature menswear looks. In 1990, white suits featured in both the Spring/Summer and Autumn/Winter collections. For Spring/Summer, Gianni styled the suits with white T-shirts and lilac, green and pink blazers, and for Autumn/Winter he designed a fluid suit shape that was oversized and had broad, defined shoulders. In later collections, such as the Spring/Summer 2005 show, the Versace collection included impeccable, classic, sand-coloured linen suits and some white tailoring worn casually with a T-shirt or with a V-neck jumper. One year later, in the Spring/Summer 2006 show, white suits were teamed up with pastel T-shirts or shirts, worn informally with the sleeves pushed up, with spectator shoes or leather sandals. For Spring/Summer 2007, the look was updated

OPPOSITE This outfit, of white denim jeans with a contrasting silk shirt, was included in Gianni and Donatella's photo book, *South Beach Stories*, shot in 1993 by Doug Ordway.

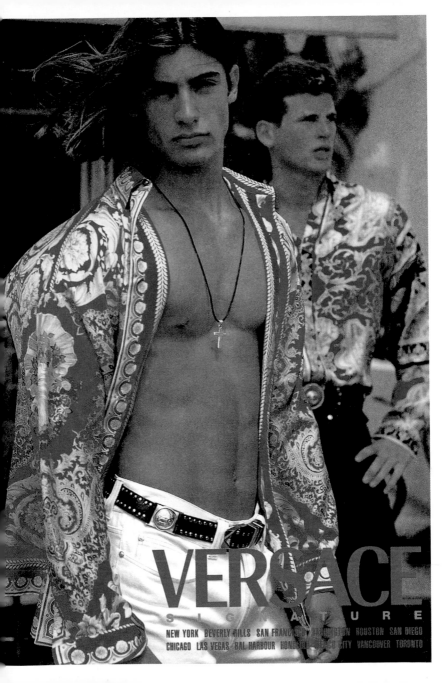

VERSACE
SIGNATURE

NEW YORK BEVERLY HILLS SAN FRANCISCO WASHINGTON HOUSTON SAN DIEGO
CHICAGO LAS VEGAS BAL HARBOUR HONOLULU MEXICO CITY VANCOUVER TORONTO

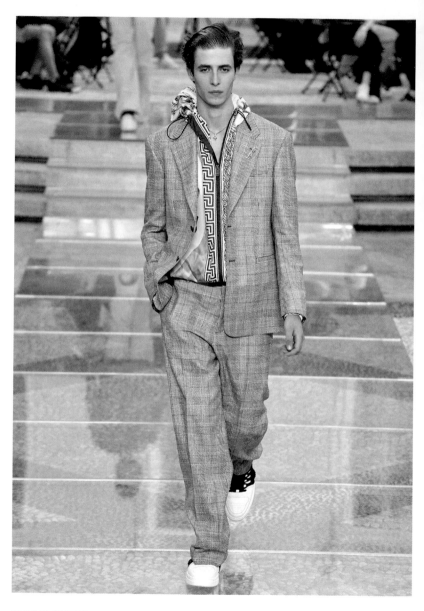

again into a more relaxed and deconstructed style that had an air of glamorous traveller about it, in soft shades of grey, light browns, pale blue and white – with accents of silver in the more formal looks.

Silk prints are very much a part of the Versace DNA and, as such, have had a significant presence in the men's shows since day one, often as an extension of Gianni's womenswear collections. The Spring/Summer 1991 show, for example, included silk shirts with Warhol imagery. Versace gold baroque patterns with intricate designs have been used to create men's shirts, whole suits, robes, and accessories such as caps and bags (Spring/Summer 2005, Spring/Summer 2006, Spring/Summer 2018). In a more up-to-date version, the same prints have re-emerged from the archive and have been printed in different colour palettes: Spring/Summer 2020 featured a polo-neck top worn with palazzo pants, in a head-to-toe rococo pastel print of soft lilacs, pinks, and shades of light blue and mint green. A brighter version of this was seen in Spring/Summer 2022, this time in tones including bright pink and lime green.

Animal prints are another Versace favourite, sometimes shown on their own (Autumn/Winter 2022), blended in with baroque designs (Spring/Summer 2005), or presented as drawings of animals, such as the tigers in Autumn/Winter 2018. Versace's Autumn/Winter 2019 show sent model João Knorr down the catwalk wearing clashing black and white striped trousers, a patterned shirt with blue retro Ford logos on it, a bold, oversized, faux-leopard-skin coat – and sporting hair dyed in a leopard pattern to match.

Versace's unapologetic love of leather inevitably made its way into the men's arena, adapting to fashion's ever-changing silhouettes. This style soon acquired a rock-and-roll following, which included musicians such as Bono, Prince, Elton John,

OPPOSITE A Prince of Wales check suit Is dressed down with a hooded top and trainers.

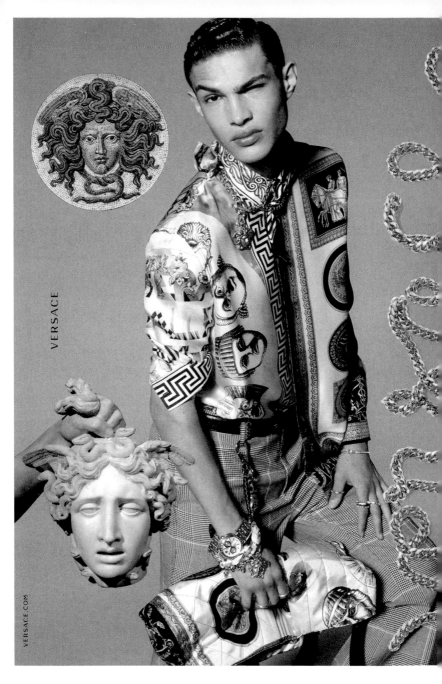

VERSACE

VERSACE.COM

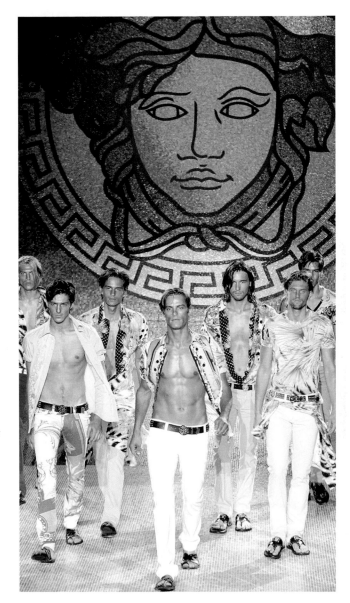

RIGHT A group of male models wear brightly coloured or patterned trousers with bold printed shirts and T-shirts for S/S 2006.

OPPOSITE Versace's Menswear S/S 2018 campaign, shot by Steven Meisel, brought together Gianni's signature style: printed silk, gold details and the Medusa head.

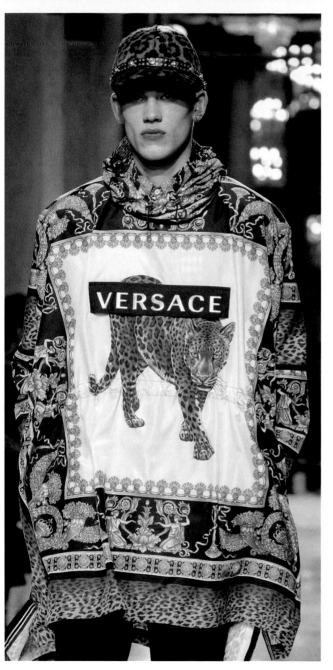

LEFT A baroque printed top from A/W 2018 displaying a picture of a leopard with the Versace logo. The model wears a matching cap.

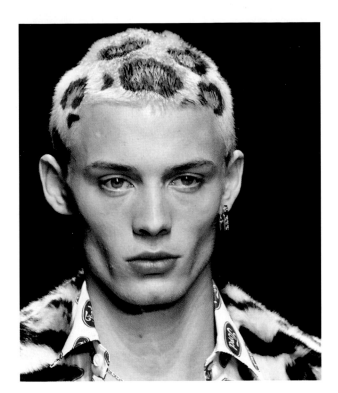

RIGHT This leopard-print coat from A/W 2019 is matched by the hair of model João Knorr, which was styled by the legendary hairstylist Guido Palau, with makeup direction by Pat McGrath.

Lenny Kravitz, One Direction singer Zayn Malik (who designed a capsule collection for Versus in 2017), and Colombian singer Maluma, the face of the 2022 men's campaign – who not only wore Versace clothes but also performed in them on stage. A true maverick, Gianni Versace loved to experiment and decorate leather, adding a fetishist dimension to the material, something the House of Versace has carried through over the decades: metal-embellished leather jackets (Spring/Summer 1983), ring-studded belts and trousers (Spring/Summer 2020), and gold and silver metal-stud patterns on trousers (Spring/Summer 1993). Gianni Versace also used leather instead of fabric to make jeans

and shirts (Spring/Summer 1993), turning something ordinary into something extraordinary. As leather became more accessible, leather jackets soon became a de rigueur staple in every man's wardrobe, and have appeared throughout the Versace brand's menswear history.

Spring/Summer 1993 included a leather jacket that combined a biker's jacket shape with metal-beaded rodeo fringing. In Autumn/Winter 2019, lengthened blazer jackets and biker jackets were worn in a show that also produced T-shirts with leather bondage straps printed on them. Belted leather trench coats were seen worn over pinstriped cotton suits (Autumn/Winter 2005), and a more minimal, futuristic, cleaner shape, à la *The Matrix*, would make way for interesting pleating and patchwork effects in the Autumn/Winter 2010 collection, where figure-hugging short leather jackets, vests and trousers were worn with metal tops, and Oroton slim scarves were seen on models with gelled-back hair.

Another menswear hallmark, characteristic of the House of Versace, is a fearless use of colour. Gianni's early collections worked with soft pastel, South Beach shades – often associated with women's clothes – and later with primary colours. For his Spring/Summer 1996 campaign, musician Prince was photographed by Richard Avedon wearing a red suit; red trousers featured again in the Spring/Summer 2005 show. More bright colours including yellows, oranges and pinks are conspicuous in collections such as Autumn/Winter 2019 and Autumn/Winter 2022, as are secondary shades in dramatic colour combinations: fuchsia and cyan blue with emerald green, or hot pink with royal blue (Spring/Summer 2021). At the 2020 Grammy Awards, artist Lil Nas X wore a fuchsia suit, complete with a cowboy hat, that was the talk of the town. Versace's prints in the Autumn/Winter 2020 show, a presentation that showcased womenswear and menswear together in a spirit of inclusivity, juxtaposed unlikely

OPPOSITE
Structured, futuristic, textured leather is worn here with sunglasses and gelled-back hair for A/W 2010.

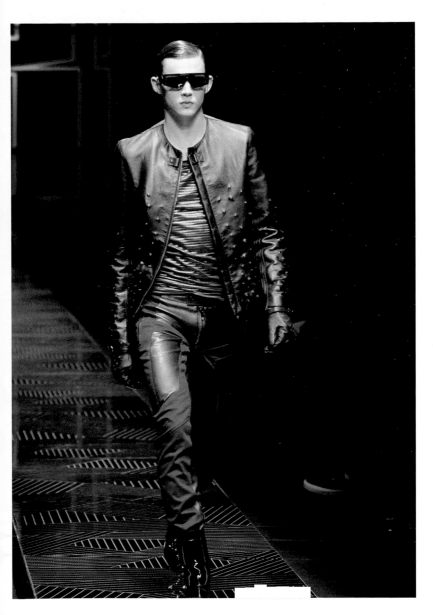

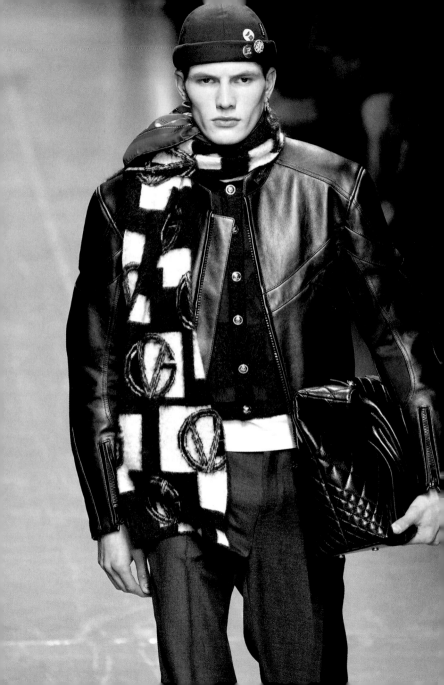

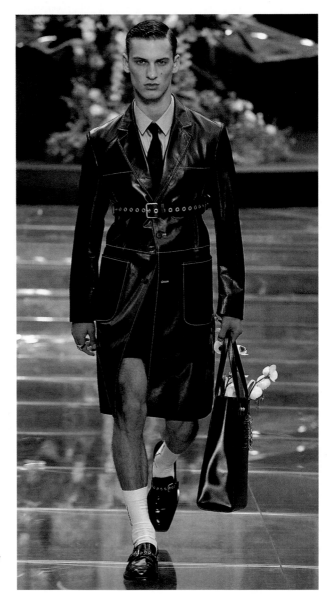

OPPOSITE An updated classic black leather jacket is accessorized with a leather bag in the A/W 2019 collection.

RIGHT The S/S 2020 collection displayed elegant shapes in innovative textures, such as this belted fitted jacket in leather with white stitching.

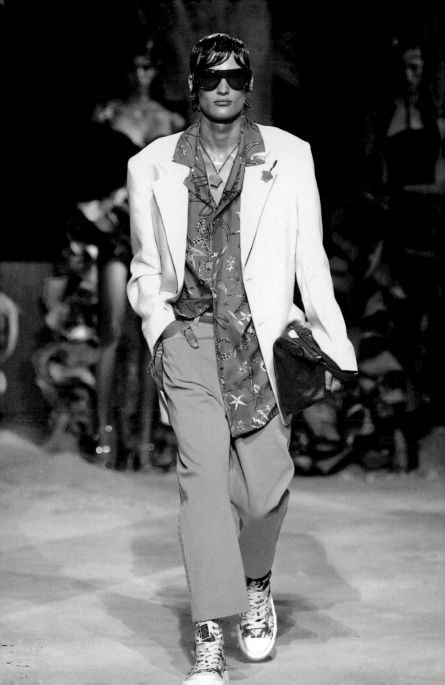

colours – such as magenta, red, lime green and turquoise – that are only usually found in harmony with each other in traditional Peruvian fabrics. Further stunning hues stole the Spring/Summer 2022 show, appearing throughout the collection and included neon suits in pink, yellow and orange that grabbed everyone's attention and that are, quite simply, genius.

Athleisure is another Versace menswear key look, which, as *Vogue* put it, "has infiltrated the runways in unexpected ways" (2016). Because of Versace's passion for quality, all garments created are luxurious, and everyday life is celebrated by creating space for sophisticated casual clothing. Many of his early Bruce Weber campaigns featured sportswear, including Gianni Versace Sport Spring/Summer 1997, shot in timeless black and white. From underwear and plush, cotton-belted bathrobes with rococo prints (Spring/Summer 2005) to knee-length Bermuda silk shorts that could pass for swimwear (Spring/Summer 2020, Spring/Summer 2022), it's a look that endures. Vests are worn with silk lounge trousers, sunglasses, and slip-on poolside shoes (Spring/Summer 2022), oversized hoodies and jackets appear in black and white zebra-like stripes (Autumn/Winter 2013) or with unapologetic branding (Autumn/Winter 2020). There are also tracksuits in embellished white (Spring/Summer 2021) or in vintage baroque prints – in green, black, gold, and blue – worn boldly with a yellow overcoat for the Autumn/Winter 2019 show, and American-style football shirts with slashed sleeves in vibrant colours (Spring/Summer 2022), all of which invite you to join Team Versace Sport.

Trainers are an extension of this aesthetic. They come in bright colours, such as a turquoise Trigreca (a chunky style launched in Autumn/Winter 2020, worn with matching socks in Spring/Summer 2022), in baroque prints (as in the Versace Greca trainer, available in high or low top and in a number of colourways, including a gold baroque print) and in white, such as the

OPPOSITE S/S 2021 combined colour with a confidence that is synonymous with the brand.

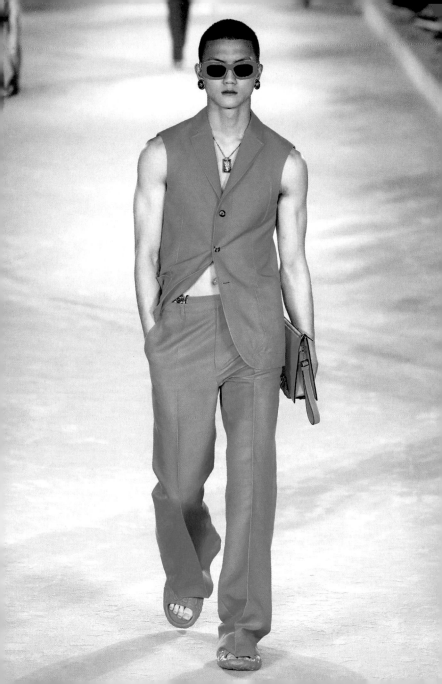

RIGHT Relaxed tailoring, seen here in bright fuchsia, featured heavily in the S/S 2022 show.

OPPOSITE This deconstructed, loose-fitting sleeveless suit in a strong aqua shade is accessorized with matching sunglasses, handbag and poolside shoes for S/S 2022.

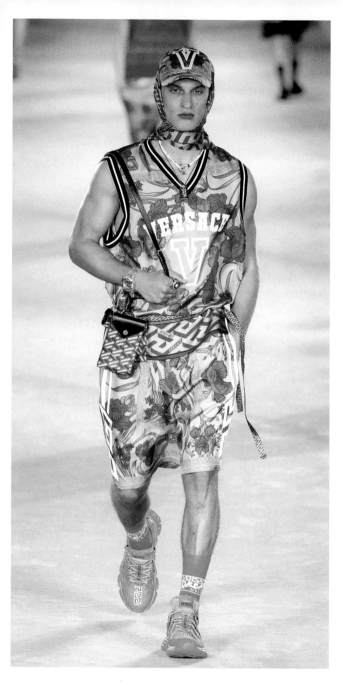

LEFT For S/S 2022, turquoise trainers and matching branded socks worn with pink shorts, vest and cap. The La Greca print can be seen on the neck scarf and accessories.

OPPOSITE Utilitarian clothing made its way on to the A/W 2020 catwalk with sporty jackets and matching trousers.

RIGHT A varsity jacket (with the "V" for Versace and a geometric trim pattern) and matching trousers in beetroot red are seen paired with a pink vest, matching sunglasses and poolside shoes for S/S 2022.

OPPOSITE Athleisure introduced casual clothing to menswear. Oversized jackets and tracksuit bottoms are worn with trainers, adding a sense of luxury to everyday fashion, as seen here in S/S 2021.

popular Chain Reaction 2. This was designed in collaboration with American rapper 2Chainz, as part of an athleisure ready-to-wear capsule collection that was launched in 2018 (the Chain Reaction 2 trainers were originally white and were relaunched in 2020 with a gold sole). Hip-hop artists such as Puff Daddy, Pharrell Williams and 2Chainz, often known for their sharp dress sense and love of "bling", have flocked to the Versace brand through the decades, being attracted to the concept of excess and sports-luxe, and have revered it ever since Tupac Shakur was invited to walk down the catwalk with his girlfriend Kidada Jones in Milan in 1995, and became the first rapper to model at a fashion show. Songs like 2013's "Versace", by Migos (who is dressed in casual head-to-toe Versace throughout the music video), brought together music and fashion, developing a particular rap style that was later described as "the Versace flow".

Recent collections, such as the post-pandemic show for Spring/Summer 2021, a co-ed presentation which was streamed live, have brought together all of Versace's emblematic menswear themes in a revised contemporary identity. The show represented the underwater journey to Versacepolis – the return to a new lost world – and staged Greek ruins, including fallen columns and a large Medusa head made of stone, alongside the runway. It featured archive prints in featherweight silk – the fitting Trésor de la Mer (Spring/Summer 1992), for example; or brightly coloured smart tailoring in fuchsia, royal blue, yellow, green and orange; or the white and pastel-pink casual suits with matching T-shirts. It also displayed retro sportswear, including scuba-style neoprene tops and white, oversized, embellished tracksuits and trainers, *Grease*-style varsity jackets and basketball tank-tops as well as leather accessories. It was a bright, happy and optimistic collection. In Donatella's own words, "These are clothes that bring you joy."

OPPOSITE A soft lilac suit, reminiscent of Gianni's early pastel looks, being modelled at the S/S 2021 show.

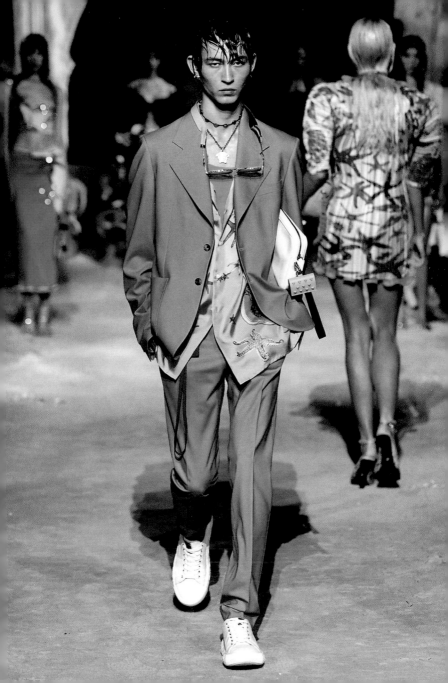

CELEBRITIES
AND POPULAR
CULTURE

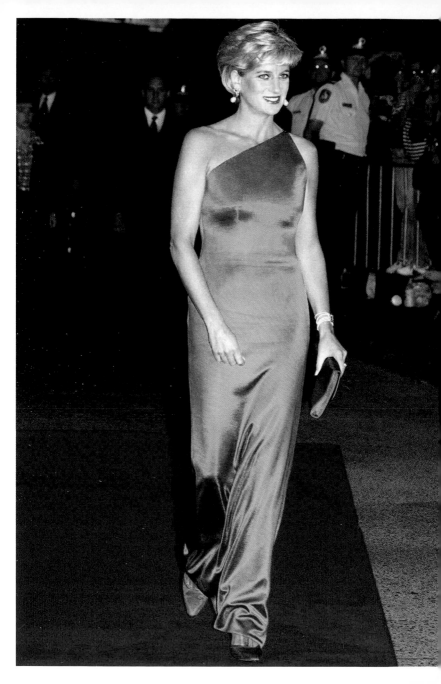

SUCCESS, FAME & GLAMOUR

"It's very important for a brand to have an identity through the years but it's very important as well to evolve because times change so fast. Everything evolves in the world and you have to be in tune with everything else." – Donatella Versace

Gianni Versace was part of the 1980s Made in Italy movement that produced extraordinary talent – including Miuccia Prada, Giorgio Armani and Paola Fendi. It was an exciting time for Italian design, with Milan repositioning itself as the fashion capital of the world. These design houses, often run as family businesses, came into their own and gained momentum, becoming synonymous with quality. They used only the best materials and worked with local factories and craftspeople, creating a powerful new image of modern, quality luxury. They were international companies with their roots firmly set in Italian soil.

OPPOSITE Diana, Princess of Wales, wearing a stunning off-the-shoulder Versace dress as she attends a benefit dinner dance in Sydney, Australia, in October 1996.

But Versace's fashion wasn't just about clothes: Versace was about bringing people and ideas together in a creative process, blending marketing with entertainment and show business. From the start, the brand had a very strong visual identity that became a sensation on the global fashion scene, attracting show business personalities and royalty worldwide, most notably Diana, Princess of Wales, who was arguably the most famous woman in the world at the time. Having divorced Prince Charles, but still attending official events, she was now free to find her own style, as she was no longer under the royal family's dress protocol. She became close friends with Gianni, and through his clothes, portrayed a bold, confident and striking version of herself, leaving behind the previous girl-next-door image and becoming his unofficial poster girl during the 1990s. For Diana, he designed some Jackie O-style fitted skirt-suits with pillbox hats, off-the-shoulder asymmetric dresses, short dresses and bodycon shapes, and – of course – the embellished icy blue and silver silk dress from his Atelier Autumn/ Winter 1991 collection that she wore for images captured by photographer Patrick Demarchelier in that same year. One of these was featured on the cover of the *Tribute to a Princess* edition of *Harper's Bazaar* in November 1997, after her death. It's thought to be the first dress Versace designed for her, and in 2015, it sold at auction for $200,000.

Versace had a symbiotic relationship with celebrities, understanding the power they held by connecting him to their audience and exchanging platforms. He invited them to sit in the front row of his star-studded shows (Madonna, Cher, Demi Moore, Uma Thurman, Joan Collins, Grace Jones, and more), and would often feature them in his advertising campaigns (Sting, Bryan Ferry, and Jon Bon Jovi sat at his Spring/Summer 1996 Atelier collection, all having just signed to star in a campaign). They were shot by the greats: Irving Penn, Richard

OPPOSITE Gianni Versace and Joan Collins at the opening of the new Versace store in London, May 1992.

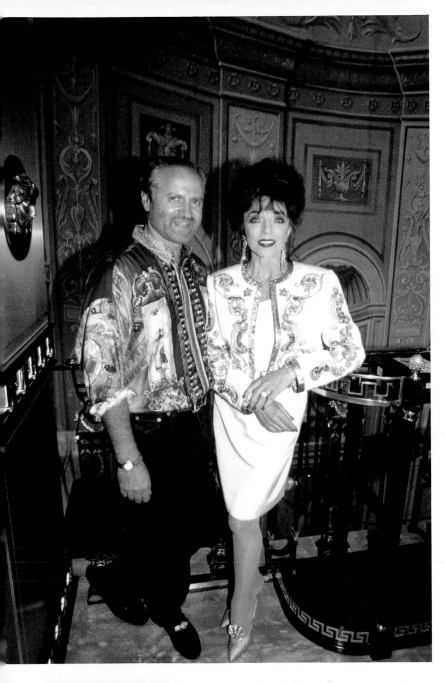

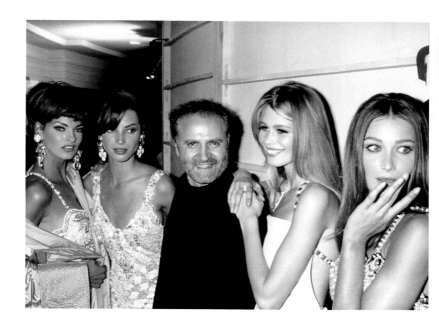

ABOVE Gianni with Linda Evangelista, Christy Turlington, Claudia Schiffer and Carla Bruni after the Atelier A/W 1991 fashion show.

Avedon, Bruce Weber, Steven Meisel, Helmut Newton, and more recently, duo Mert Alaş and Marcus Piggott. Gianni also rewrote the rules in transitioning models from the catwalk to the editorial world, raising their profile and creating "the Supers". Fashion photography became his way of expressing and communicating his aesthetic, creating timeless images that would become part of popular culture. He and Donatella, who kept him connected to the celebrity circuit, would work closely and meticulously with the photographers up to three months before a campaign was shot, and referred to them as great artists who brought a voice to Versace fashion.

Previously, fashion – especially couture – had been something reserved for the higher echelons of society. Now, Gianni Versace was turning this concept on its head, creating a new visual code that would appeal to a broader audience, by aligning himself

with celebrities, and influencing them as much as he was being influenced. As *Vogue* Editor-in-Chief Anna Wintour said, "Gianni understood the importance of fashion as a global package. He was the first to introduce superstars on the runway, he was the first to bring the celebrities into the front rows, he was the first to use the rock stars and the actresses in his advertising campaigns."

"You can really talk to all the world with one picture and you need a great voice, and Avedon, Weber, Newton … they're all great and we use them."'

– Gianni Versace

When casting models or celebrities, the Versaces were not only attracted by beauty but also by strength of character. They often used models who were new to the trade and brought a fresh, unaffected energy to the shows. These models were always treated as part of the family and told to just be themselves. Madonna, as an example, has featured in four campaigns for Versace to date. The first one, in Spring/Summer 1995, was shot by Steven Meisel, mostly in black and white and on location in Florida, where the artist embodied Jean Harlow's early Hollywood femme-fatale glamour. In her platinum-blonde look, she appears very much at home – wearing enchanting frocks, playing backgammon against a dog, posing in a bikini with a poodle and painting its nails, reclining on some steps, or playing croquet on the lawn. In Autumn/Winter 1995, she was the face of Versace again, this time in a modern, clean shoot. It featured mostly headshots, in some of which she is wearing a tiara, in

a studio photo shoot by Mario Testino. Another Madonna for Versace campaign shot by Testino took place in 2005, where she portrayed a powerful businesswoman busy at work. Ten years later, she was shot wearing dark lipstick by Mert Alaş and Marcus Piggott in a black and white, graphic, seductive story, reflecting her beauty and spirit.

Another remarkable performer, Lady Gaga, fronted the Spring/Summer 2014 campaign. One of the looks in the shoot – a soft, lilac look – was reminiscent of Madonna's violet dress in her first Versace campaign. Here, Lady Gaga leans on a sofa with long, poker-straight, bleach-blonde hair, à la Donatella, shot by Mert Alaş and Marcus Piggot. Another print ad in this series features her surrounded by pastel-coloured Versace handbags, looking into the distance. In a bold move, Lady Gaga – a longstanding friend of the Versace clan – chose to wear a red corset dress, that was indisputably Versace, as one of the outfits to promote her film *House of Gucci* in 2021.

In 1995, Versace's homeware advertising campaign starred Sylvester Stallone and Claudia Schiffer, who were photographed by Helmut Newton. They posed naked with strategically placed Versace china. Claudia, with her long, wavy blonde hair, is smiling while holding a bitten apple into the air – a controversial image, loaded with biblical symbolism for the forbidden fruit. This campaign was recreated in 2022, in a picture starring models Bella and Gigi Hadid, shot by Mert Alaş and Marcus Piggott. This time, the sisters are in the garden of Eden holding handbags from the latest collection to conceal their body, and together they're holding up a red apple that hasn't yet been bitten, while a snake is sliding up Bella's leg.

With the internet revolution and the rise of social media, fashion and popular culture have been redefined yet again. Virtual relationships have become a big part of how we all

OPPOSITE Madonna wearing a glamorous dress, photographed by Steven Meisel in 1995 for the S/S campaign, which was shot in Palm Beach.

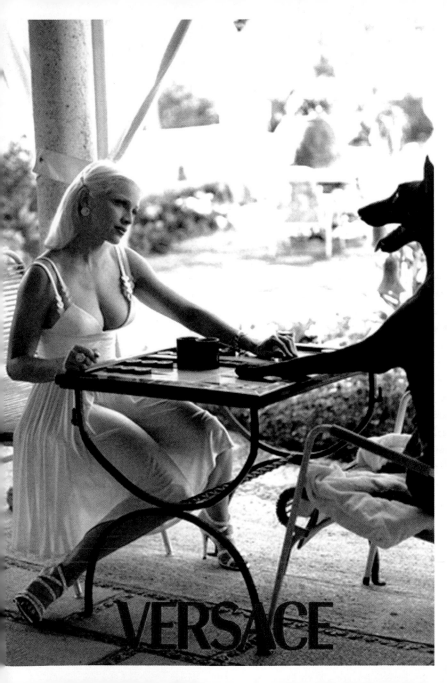

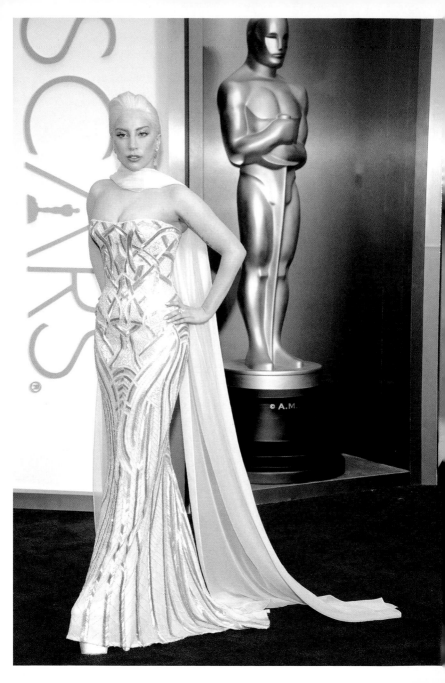

stay connected: shows are streamed live and sales take place immediately. We can even send a direct message to Donatella via Twitter or Instagram. In fact, Donatella replies to a piece of fan mail once a month, and has confessed to having adapted her vision of the House of Versace's direction according to the feedback she receives. But now more than ever, Versace's concept of family – and sometimes of the virtual family – remains integral to the brand. It was portrayed as a theme in the Spring/Summer 2022 campaign, in which celebrity supermodel sisters Gigi and Bella Hadid modelled alongside Donatella herself, reflecting the values that lie at the heart of the brand. Versace also connected music and fashion in an unprecedented

"Family is always at the heart of everything I do, which is why I love Bella and Gigi so much. They perfectly exemplify the strength between sisters, and they share that message to our Versace sisterhood worldwide."
– Donatella Versace

OPPOSITE Lady Gaga attends the Academy Awards in March 2014 wearing a fitted, shoulderless, full-length gown in dusty pink with gold detailing.

way, making it a central part of all their events. Elton John and Jon Bon Jovi played an acoustic set at the opening of Gianni's new Fifth Avenue store in New York (October 1996), and Lenny Kravitz played at a Rock N' Rule Benefit fashion show for amFAR (Foundation for AIDS Research) at Park Avenue Armory in New York (September 1992), and again at the Versus Autumn/Winter 2000 show. Donatella's love of music was no doubt a strong influence in the merging of genres. She is reported to always have loud music playing in the background, like a soundtrack to her life. In her own work,

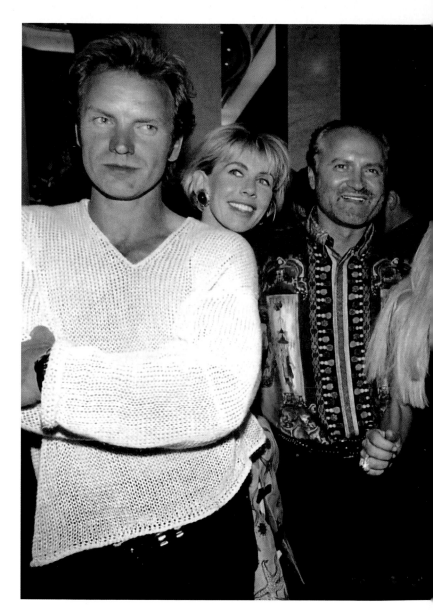

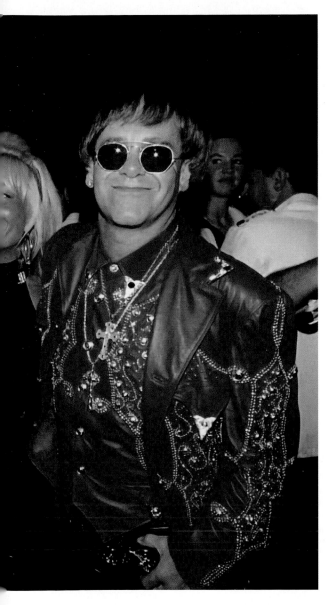

LEFT The Versaces loved to party with celebrities. Here, Gianni and Donatella pose with Sting, his wife Trudie Styler, and Elton John.

since debuting the Versus collection in 1989, she has involved music in all the fashion performances.

Original tracks have been written for Versace shows, including Elton John's "Into the Jungle (for Gianni Versace)" (1995) and The Versace Experience soundtrack, which was created by

> **"For me, Versus has always been about bringing together the worlds of fashion and music. From our first-ever Versus shows in New York in the '90s, we had bands playing and a crowd of club kids rather than the usual fashion audience."**
>
> **– Donatella Versace**

Prince exclusively for the Autumn/Winter 1995 show. Prince and Donatella were close friends, and in Spring/Summer 2017, soon after his sudden death, she paid tribute to him at her menswear show by playing some unreleased tracks he'd sent her. In a heartfelt gesture, she closed the show walking the catwalk styled to look like him, wearing a purple suit and a black ruffled-collar blouse.

Artists such as Elton John, Michael Jackson (Versace custom-made the gold outfit he wore on his HIStory World Tour), Bruce Springsteen, Paul McCartney, Madonna, Bruno Mars (writer and performer of one of Donatella's favourite songs, "Versace on the Floor"), Jennifer Lopez, Robbie Williams, Lady Gaga and One Direction's Zayn Malik have all expressed their love for the brand by wearing it on stage. Lady Gaga also dedicated a track to Donatella on her album *Artpop*. For the Spring/Summer 2022 presentation, Donatella enlisted superstar singer Dua Lipa (the face of the Versace campaign in

OPPOSITE Hugh Grant and his girlfriend, Elizabeth Hurley, attend the premiere of Grant's latest film, *Four Weddings and a Funeral*, in London, May 1994. "That dress" would make every newspaper headline the following day.

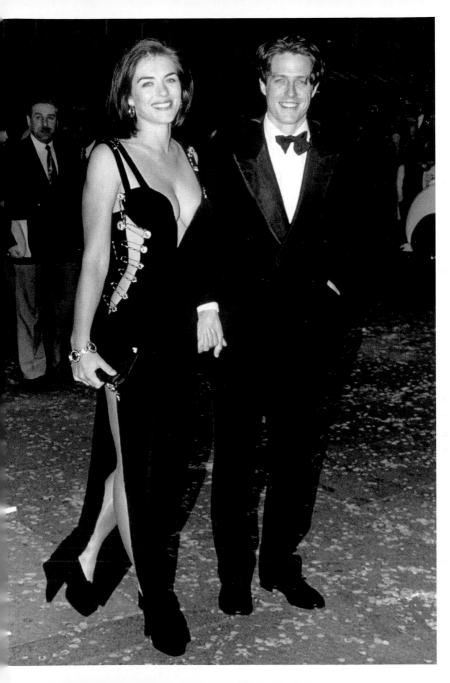

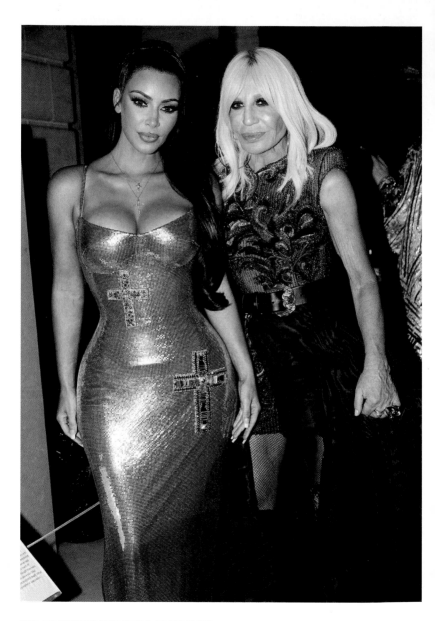

Autumn/Winter 2021) to open and close the show to her own music, and singer Maluma is the face for Versace Men's Spring/ Summer 2022.

If you want to get noticed on the red carpet, Versace is a go-to brand. From the Academy Awards to the BAFTAs, Golden Globes, the Cannes Film Festival, the Met Gala or the Grammys, few designers are more fitting for the occasion. Aside from the more traditional, spellbinding Atelier looks that guarantee some paparazzi interest, Versace will often make the showbiz headlines with unusual, playful theatrics such as outfit changes. Lil Nas X wore three Versace outfits at his first Met Gala red carpet appearance in 2021: he arrived in an ornate, golden high-collared long cape, which he took off to produce a futuristic golden suit of armour, which was, in turn, removed to show a striking jewelled bodysuit. And in 2022, Dua Lipa and Megan Thee Stallion met up on stage at the Grammys to co-present the award for Best New Artist, wearing the same on-trend Versace Vintage-inspired dress (recreating a scene in the 1998 MTV Awards where Whitney Houston and Mariah Carey wore the same dress) and, in a stunt, each removed a section to make them look different. This time Dua Lipa said: "I was told I had the exclusive … I'm going to have to have a talk with Donatella," signalling to Donatella to join them on stage to resolve the face-off by tearing their skirts off and creating two brand-new looks. "You know what," said Donatella, "Let's do this and this. Now: these are my girls."

The high street has often been influenced by Versace, but in 2011, queues formed outside H&M, owners of over 3,000 stores worldwide, welcoming an affordable, limited-edition capsule range of Versace designs. Drawing on the classics, it was a glamorous, hot collection replete with gold, studs and colourful prints. The fashion presentation took place in New

OPPOSITE Kim Kardashian (in a classic chainmail Versace dress) and Donatella attend the Met Gala, whose theme was "Heavenly Bodies: Fashion and the Catholic Imagination", in New York City, May 2018.

York, in a star-studded evening attended by Jessica Alba, Blake Lively, Uma Thurman and Nicki Minaj, and followed by a surprise performance from Prince.

Spring/Summer 2022 witnessed another exciting collaborative culture exchange, this time between fashion houses Fendi and Versace, an effort dubbed "Fendace". The "Fendace" show closed Milan Fashion Week that year and took place at Versace's family palazzo on Via Gesù. Donatella and Fendi's designers, Kim Jones and Silvia Venturini Fendi, worked together to produce 50 looks reflecting both brands. The catwalk was stellar, and included Amber Valletta, Kate Moss and her daughter Lila Moss Hack, Naomi Campbell, Gigi Hadid and Precious Lee.

Such is the fascination with Gianni Versace's life and dynasty that in 2018, a television series was made of Gianni's life: *The Assassination of Gianni Versace: American Crime Story*. It is based on the book *Vulgar Favors: Andrew Cunanan, Gianni Versace, and the Largest Failed Manhunt in U.S. History* by Maureen Orth, and stars Penelope Cruz as Donatella, Ricky Martin as Versace's longstanding partner Antonio D'Amico, Edgar Ramirez as Gianni Versace and Darren Criss as murderer Andrew Cunanan. It follows the life of Cunanan – a pathological liar, conman and spree killer – until he reached Versace in Miami and then killed himself after a three-day police chase without ever offering an explanation for his actions. The series was shot in Versace's Miami mansion, which is now a hotel. It was positively received and won three Grammy Awards after receiving nine nominations.

For the fashionistas out there, Nicola Peltz married Brooklyn Beckham in April 2022 wearing a pair of spectacular off-white satin Versace Medusa Aevitas platform pumps (also spotted on Ariana Grande and Beyonce). Versace was also immortalized

RIGHT Lil Nas X attends the 2021 Met Gala, celebrating the theme and exhibition "In America: A Lexicon of Fashion" at the Metropolitan Museum of Art in New York City, September 2021. He wears a theatrical custom Atelier Versace outfit consisting of three stages: a regal satin cloak, a golden suit of armour and a sequinned bodysuit.

in TV history by the iconic grey princess tulle and chiffon *Mille-Feuille* dress worn by Sarah Jessica Parker, playing Carrie Bradshaw, in the *Sex and the City's* series finale in 2004. It was a soft grey Atelier gown and, at $80,000, the most expensive dress in the whole HBO show. It was also the stylist, Patricia Field's, favourite – a dress that depicted the height of glamour and hope for a new relationship. Carrie, the main character, follows her boyfriend from NY to Paris, but despite her best efforts, the romance doesn't work out. Devastatingly, she doesn't get to wear the dress on her date that evening as planned, and instead is left sitting on the bed in her hotel room, the dress covering its entire length. The revival series and sequel to *Sex and the City, And Just Like That…*, features the dress again when Carrie, while attempting to archive some of her designer clothing, says to her estate-agent friend Seema (Sarita Choudhury), "Do you want to see something amazing? I don't want to brag, but it is my pride and joy." And she produces the rippling dress. Donatella also had a cameo role in the fashion spy comedy *Zoolander* (2001) directed by and starring Ben Stiller.

August 2007 saw a Donatella Versace *Simpsons*-style-cartoon in *Harper's Bazaar*, in time for the premiere of *The Simpsons* movie. It was a comic-style article entitled "The Simpsons go to Paris with Linda Evangelista". Here, her cartoon poses in a black shoulderless dress alongside a cartoon version of Linda Evangelista – with Marge Simpson holding a champagne flute and living "La Vita Versace". A few years later, in 2012, illustrator AleXsandro Palombo also replicated this style of cartoon, and included Donatella and her daughter Allegra in a satirical collection of the most influential people in the fashion industry. It was featured in *Vogue* magazine.

OPPOSITE Dua Lipa wearing an iconic vintage bondage Versace dress from 1992 at the 2022 Grammys.

FRAGRANCE
AND
INTERIORS

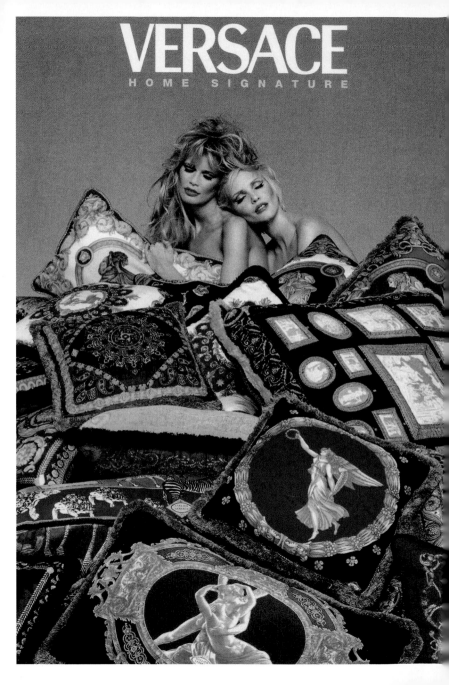

THE VERSACE LIFESTYLE

"Perfume puts the finishing touch to elegance – a detail that subtly underscores the look, an invisible extra that completes a man and a woman's personality. Without it there is something missing." – Gianni Versace

No prominent fashion house would be complete without a line of fragrances and interiors to encapsulate the label's dream and make it accessible to everybody.

In 1981, Gianni Versace, an eau de toilette for women was introduced, a chypre floral scent. It was followed by Versace L'Homme in 1984, a classic, masculine woody fragrance created by perfumer Roger Pellegrino, also designer of Cacharel's classic scent Anaïs Anaïs. A number of perfumes and eau de toilettes for men and women followed under the Versace, Versus, Jeans and Jeans Couture labels, which since 2005 have been produced in partnership with Euroitalia, one of the largest businesses in the world for luxury designer fragrance. Names included Versace Eros, Versace Eros Pour Femme, Versace Crystal Noir, Versace the Dreamer, Versus Versace, Dylan Blue and Versace Yellow Diamond.

OPPOSITE Gianni's Home Collection campaigns were as emblematic as any of those he did for clothing collections. His opulent prints with gold accents became accessible to all who wanted to experience the Versace lifestyle.

"This is a new milestone for Versace that stems from the idea that every woman and man is different and that, in the same way that they like to get their dress made-to-measure, that's even more true when it comes to fragrances."

– Donatella Versace

As with Versace fashion, the advertising campaigns for the fragrances had a strong narrative and were shot by the best photographers in the business. No detail was overlooked, and even the bottles have become instantly recognizable and synonymous with the brand: for instance, the 1990s glass bottles for the Blue Jeans and Red Jeans perfumes, with the Medusa logo embossed on them. Some of the best campaigns include Richard Avedon's black and white Blonde campaign in 1995, featuring a stunning, windswept Donatella (images of which were printed on T-shirts for Versace's Autumn/ Winter 2019 collection); the Eros Pour Femme in 2014, modelled by Lara Stone and Brian Shimansky wearing golden gladiator sandals (shot by photographer duo Mert and Marcus); and the Dylan Turquoise Eau de Toilette campaign, which launched in 2021. This 2021 campaign was photographed by Harley Weir, known for her compelling compositions and youth-focused fashion photography. It projected a carefree, holiday feel and was modelled by Hailey Bieber and Bella Hadid in swimwear, against a backdrop of sunny blue skies and heavenly Sardinian beaches.

OPPOSITE Lara Stone fronts Versace's Eros Pour Femme advertising campaign – photographed by Mert Alas and Marcus Piggot – wearing a classically inspired Versace dress with gold embellishment and gladiator high heels.

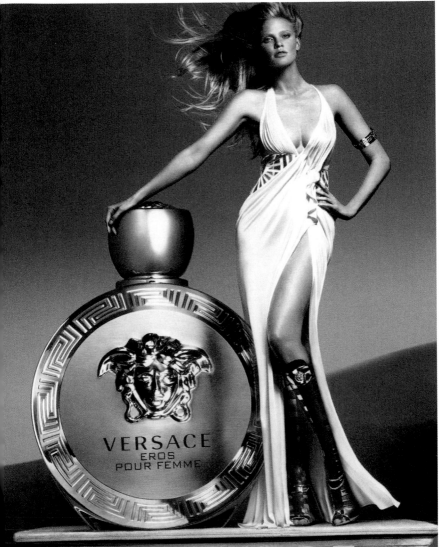

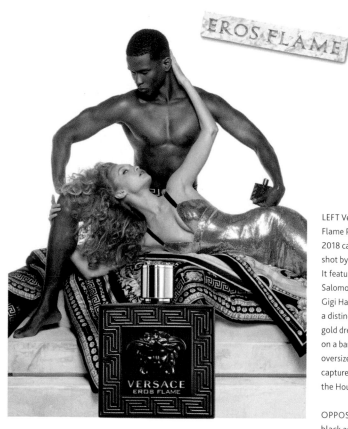

VERSACE

EROS FLAME

POVR HOMME

LEFT Versace's Eros Flame Pour Homme 2018 campaign was shot by Steven Meisel. It featured models Salomon Diaz and Gigi Hadid – wearing a distinct Oroton gold dress – reclining on a baroque-print oversized throw that captures the essence of the House of Versace.

OPPOSITE A classic black and white campaign for the Versace fragrance Pour Homme Dylan Blue, 2016.

VERSACE
pour homme
DYLAN
BLUE

+44 (0) 20 7730 1234 harrods.com

Harrods
Worldwide Exclusive

Six new contemporary, genderless, upscale and unisex haute perfumes were launched under Atelier Versace in 2019, reflecting Donatella's support for individualism and self-expression.

They each focus on one key ingredient that acts as the centre point (and the name of the scent): Cédrat de Diamante, Éclat de Rose, Jasmin au Soleil, Figue Blanche, Santal Boisé or Vanille Rouge. All six are designed to complement each other and can be worn as one or – as Donatella does – can be worn overlaid. The glass bottles – reminiscent of neoclassical columns – are hand-made using an innovative twisting technique and display a Greek motif painted by hand. The packaging is also hand-finished; inside the boxes is a mirror with the Atelier Versace diamond-shape logo, which exudes pure luxury. This, of course, comes at a price: £320 per 100ml bottle. The campaign was fresh and modern, reflecting the Atelier values of artisan work and family tradition, featuring models and Versace's atelier

ABOVE Milan Design Week 2018 included a Versace Home stand displaying the furniture and homeware so characteristic of the brand's aesthetic.

tailors together in synergy. The shoot, as always, was designed by Donatella; it was styled by her daughter Allegra and photographed by Thurstan Redding, who also directed the video – an intimate, friendly, sympathetic snapshot of the Atelier staff at work, discussing the new perfume line.

The Versace Home Collection is another extension of the Versace empire, designed to add luxury and glamour to any space. Heavily branded, it includes a vast range of accessories, from bathrobes and bedding to luxury tableware, cushions, furniture, wallpaper, ceramic tiles, lighting and home décor, all created to attain a Versace look. The Versace Design Studio goes even further, offering a private, residential interior-design service. Its work portfolio includes spectacular buildings such as the ABIL Mansion in Mumbai, the Amaryllis iconic tower in New Delhi and the Milano Residences in Manila.

There are also two five-star Palazzo Versace luxury hotels. The first one opened in September 2000, on Australia's Gold Coast,

BELOW Timeless and elegant furniture pieces, lighting and home accessories from Versace.

fittingly employed to host the contestants of *I'm a Celebrity…
Get Me Out of Here!*, symbolizing the extremes in lifestyle
between Versace's luxe opulence and life in a simple jungle camp.
It has private suites and condominiums, spas, a Versace boutique
and valet parking, and is decorated in glamorous Versace style,
with framed fashion sketches and bespoke Italian furnishings.
As you enter, you're welcomed by the Medusa – etched on the
glass door and on a floor mosaic in reception. Dubai's Palazzo
shares the same aesthetic. An imposing neoclassical palace built
on the banks of the Dubai Creek, this hotel took seven years
to build and opened in March 2015. It features three outdoor
swimming pools, 215 rooms and suites – including two Imperial
Suites – and 169 private residences with up to six bedrooms
each, offering an insight into the Versace world and, of course,
a taste of the incredible, seductive Versace dream that embodies
Gianni's love of freedom, beauty and quality.

OPPOSITE Gianni
Versace was a
maverick creator
who, in his own words,
never took himself
"too seriously" and
was still a "child
who loved to play
with fashion".

BELOW The interior
of the Palazzo
Versace in Dubai.
Intricate designs on
soft furnishings and
flooring encapsulate
the opulent Versace
lifestyle.

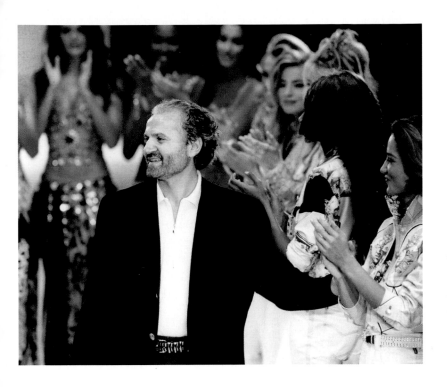

"Some say Versace is a genius, some say Versace has no talent. But I believe neither the one nor the other. I believe in working every day, I believe in excitement, in everything that makes me happy as a man and as a designer."

– Gianni Versace

INDEX

CREDITS

The publishers would like to thank the following sources for their kind permission to reproduce the pictures in this book.

Alamy: MirrorImages 12; Retro AdArchives 14, 80-81, 103, 106, 133, 148, 151, 152, 153

Getty Images: AFP Contributor 79; Pool Arnal/Pat 53, 130; Pool Arnal/Picot 57; Michel Arnaud 26, 44, 55; Dave M. Benett 18, 47; 22-23; Marco Bertorello 95; Victor Boyko 104, 112; Gareth Davies 139; Estrop 116, 118, 121; Noam Galai 143; Scott Gries 71; Frazer Harrison 144; Estate Of Evelyn Hofer 10-11; Images Press 28; Taylor Jewell 140; Gerard Julien 54; David Lees 9; Pier Marco Tacca/Stringer 154; Kevin Mazur 134; Miguel Medina 85, 86; Mondadori Portfolio 6, 117; Filippo Monteforte 100, 107; John Phillips 119; Duncan Raban/Popperfoto 129; Vittoriano Rastelli 39; Jacopo Raule 96-97; Daniel Simon 68, 69; Andrew Stawicki 157; Daniele Venturelli 111; Victor Virgile 75, 76, 83, 94, 109, 113

Kerry Taylor Auctions: 35

Shutterstock: 126; Jacques Brinon/AP 72, 73; Luca Bruno/AP 64, 67; Alan Davidson 136-137; ECE Design 4 (motif repeated throughout book); Riccardo Giordano/IPA 89, 91; Kamni Jethani 156; Tony Kyriacou 25; Guy Marineau/Condé Nast 31, 36, 37, 42, 43, 50, 52, 58, 61; Neville Marriner/ANL 29, 51; Paul Massey 40-41; Olycom Spa 155; Irving Penn/Condé Nast 32; Pixelformula/Sipa 108; SGP 88; Ken Towner/ANL 48; Courtesy Versace/SIPA 114, 120, 123;Steve Wood 21, 24; Vittorio Zunino Celotto 92

Every effort has been made to acknowledge correctly and contact the source and/or copyright holder of each picture and Welbeck Publishing apologises for any unintentional errors or omissions, which will be corrected in future editions of this book.